Treasury of
CHINESE DESIGN MOTIFS

Treasury of
CHINESE DESIGN MOTIFS

by
Joseph D'Addetta

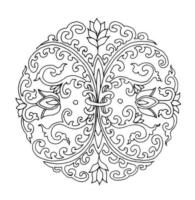

DOVER PUBLICATIONS, INC.
NEW YORK

Published in Canada by General Publishing Company, Ltd., 30 Lesmill Road, Don Mills, Toronto, Ontario.
Published in the United Kingdom by Constable and Company, Ltd.

Treasury of Chinese Design Motifs is a new work, first published by Dover Publications, Inc., in 1981.

DOVER *Pictorial Archive* SERIES

International Standard Book Number: 0-486-24167-X
Library of Congress Catalog Card Number: 81-66566

Manufactured in the United States of America
Dover Publications, Inc.
31 East 2nd Street
Mineola, N.Y. 11501

Publisher's Note

During the thousands of years that China has been one of the world's great artistic centers, its vocabulary of design motifs has expanded to phenomenal proportions. In the present volume the artist Joseph D'Addetta offers his own careful and sensitive pen renderings of motifs taken from fine authentic examples of Chinese art objects in leading museums and private collections. Motifs from ceramics and textiles are most heavily represented, but there are also examples from jade, lacquer, bronzes and furniture. Many phases of Chinese history are included, beginning about 1300 B.C., although Ming and Qing dynasty examples (14th through 19th centuries) predominate.

The plates are arranged according to the following categories (based on the main motif of the plate): Flowers and Plants (Plates 1–29), Animal Life (30–49; includes dragons, lion, fish, birds, insects and bats), Wave and Cloud Forms (50–55), Symbols (56–62), Medallions (63–71), Allover Patterns (72–75), Horizontal Bands (76–82) and fully rendered Ceramic Objects (83–100).

In identifying dynasties and periods within dynasties, the present volume uses the *pin yin* transcription system, which was developed within recent decades in mainland China and is gaining practically total currency in the world of museums, art galleries and auction houses, not to mention forward-looking newspapers and other publications. To aid those who have grown up with the 19th-century Wade system, used in older books on Chinese art, both systems are shown in the list on page vii, which includes only dynasties and periods represented in this book.

Dynasties and Periods Represented in This Book

The *pin yin* transcription (used in the captions) appears first, followed by the Wade transcription for purposes of reference (within parentheses), which is in turn followed by the time period of each dynasty or period expressed according to the Western calendar.

ZHOU (CHOU) DYNASTY, 1122–256 B.C.

TANG (T'ANG) DYNASTY, 618–907 A.D.

SONG (SUNG) DYNASTY, 960–1279

Northern, 960–1127
Southern, 1127–1297

YUAN (YÜAN) DYNASTY, 1280–1367

MING (MING) DYNASTY, 1368–1643

Yong lo (Yung Lo) period, 1403–1424
Xuan de (Hsüan Tê) period, 1426–1435
Cheng hua (Ch'êng Hua) period, 1465–1487
Hong zhi (Hung Chih) period, 1488–1505
Zheng de (Chêng Tê) period, 1506–1521
Jia jing (Chia Ching) period, 1522–1566

QING (CH'ING) DYNASTY, 1644–1912

Kang xi (K'ang Hsi) period, 1662–1722
Yong zheng (Yung Chêng) period, 1723–1735
Qian long (Ch'ien Lung) period, 1736–1795
Tong zhi (T'ung Chih) period, 1862–1874

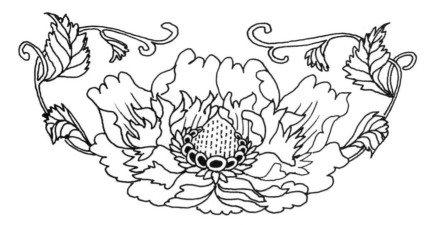

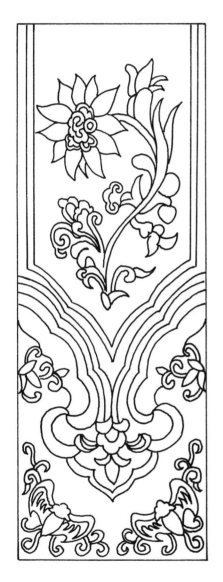

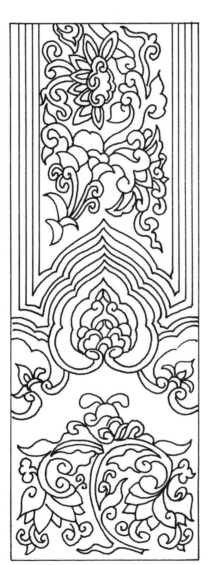

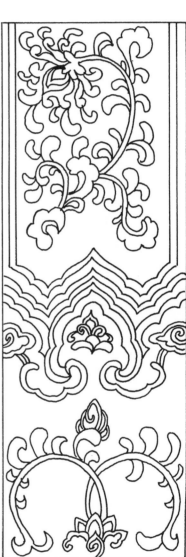

TOP: Motif from a porcelain of the Kang xi period of the Qing dynasty. BOTTOM: Three floral motifs.

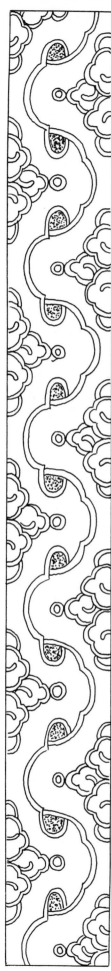
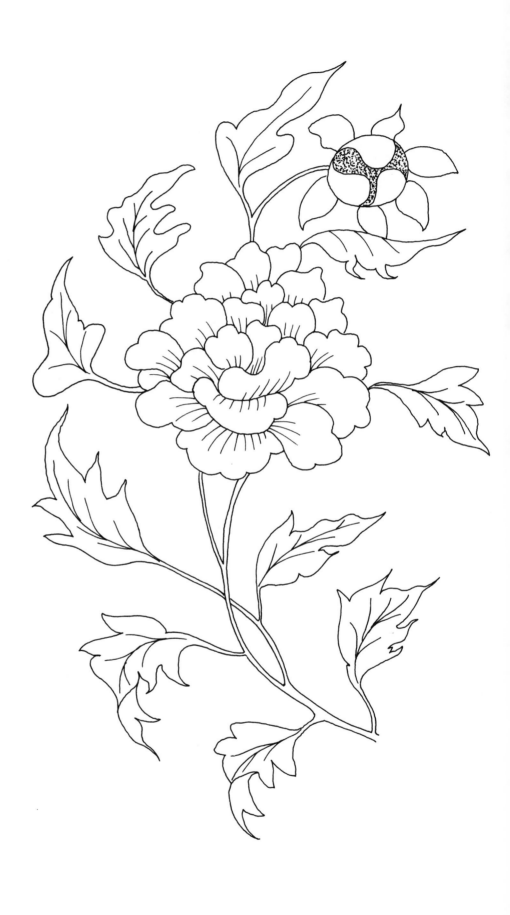

Peony from a Ming dynasty porcelain. BORDER: "Cloud collar" from a 15th-century (Ming dynasty) porcelain.

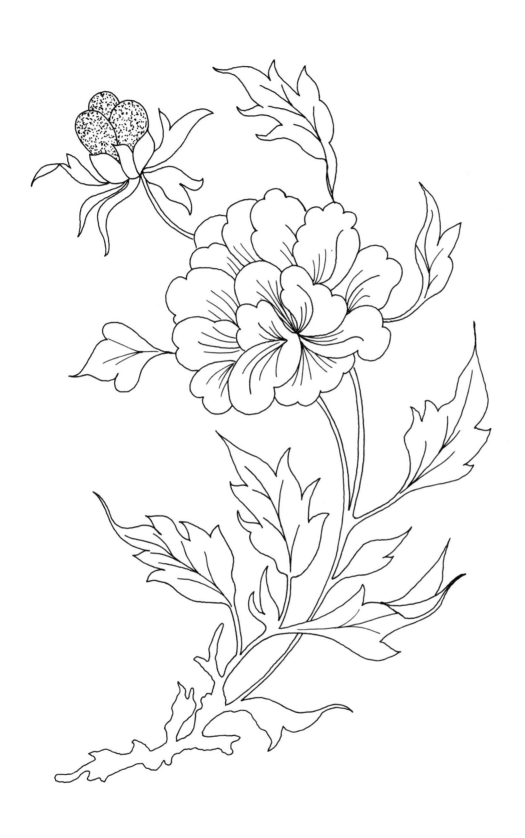

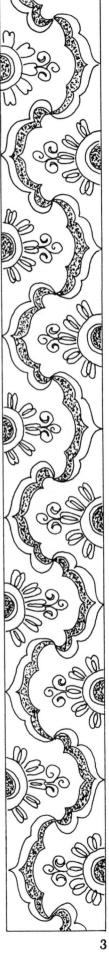

Peony from a Ming dynasty porcelain. BORDER: "Cloud collar" from a 15th-century
(Ming dynasty) porcelain.

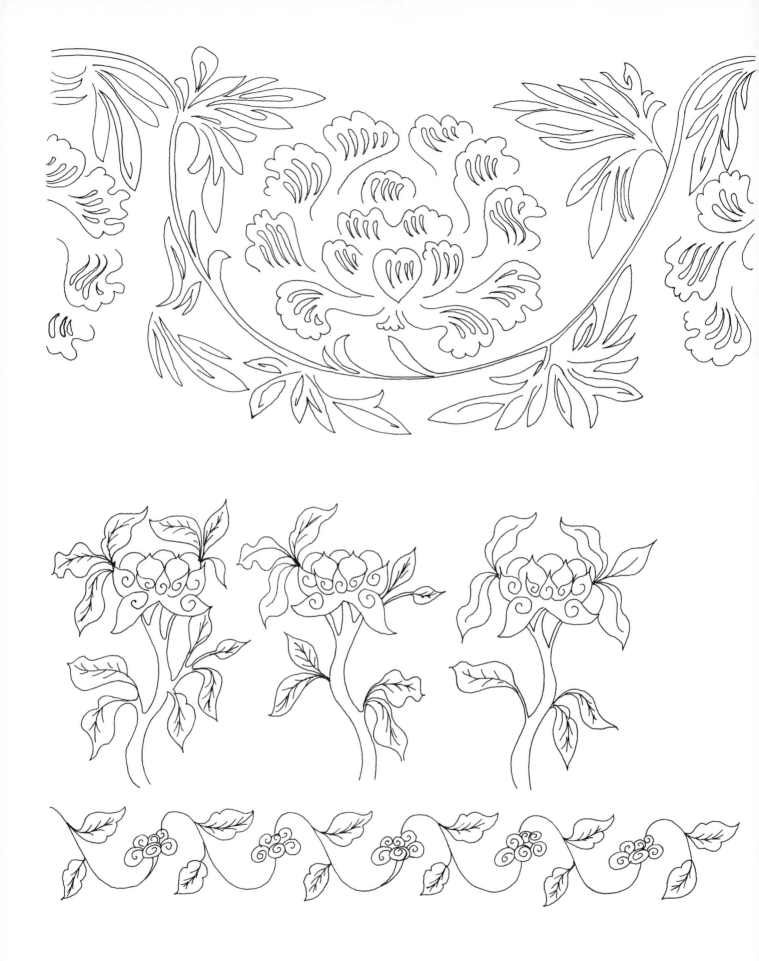

TOP: Peony scroll from a porcelain of the Northern Song dynasty. CENTER & BOTTOM: Motifs from Song dynasty pottery.

4

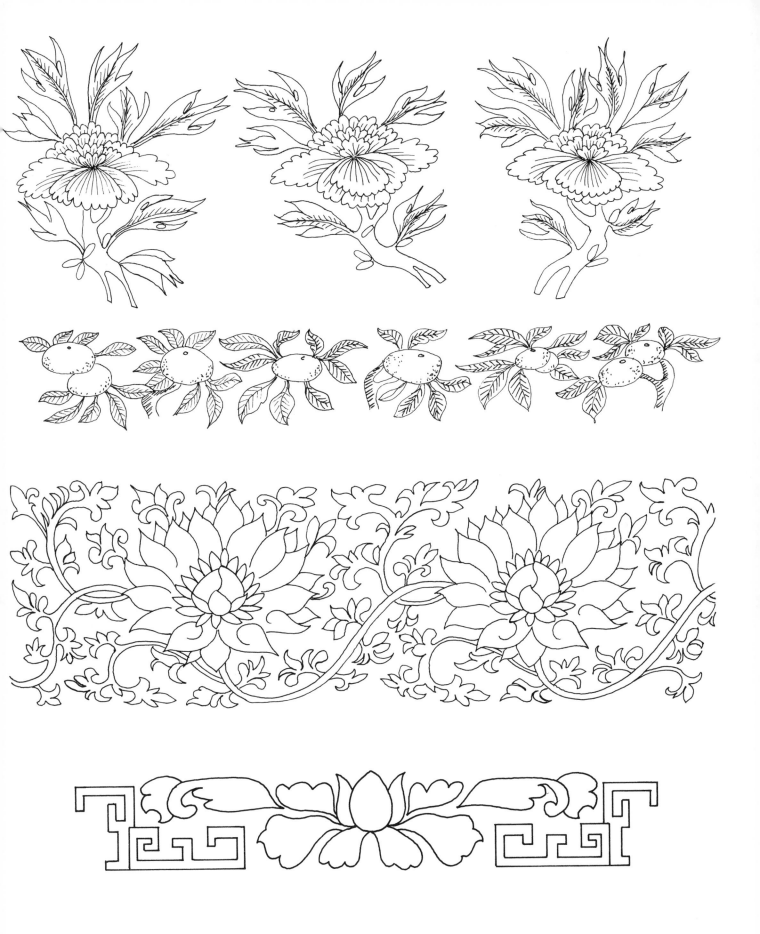

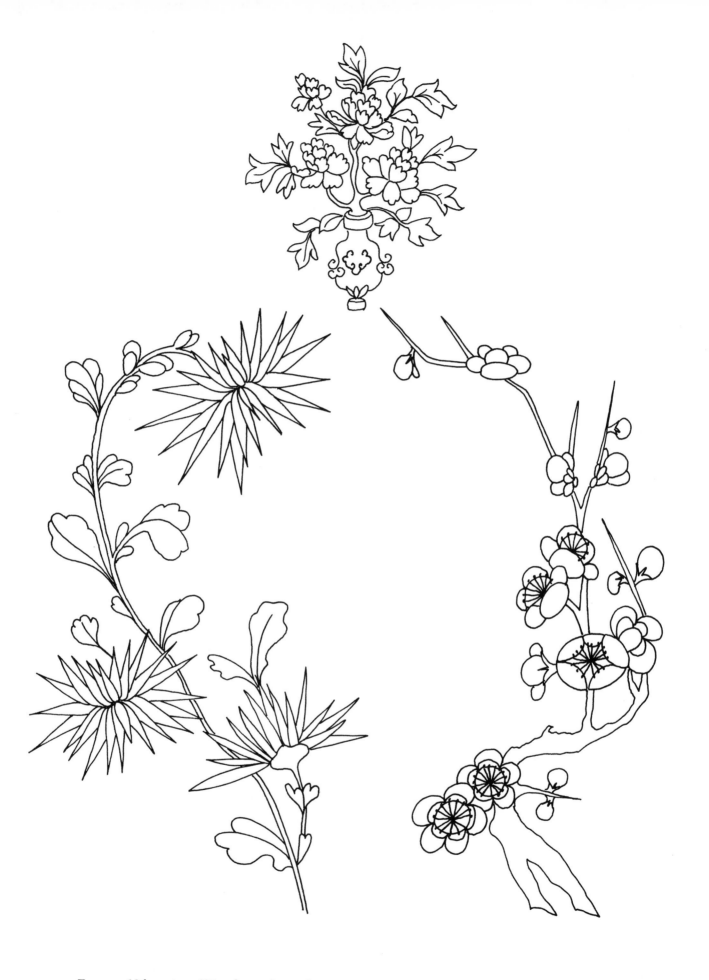

TOP: From an 18th-century (Qing dynasty) porcelain. BOTTOM: Two motifs from 19th-century (Qing dynasty) textiles.

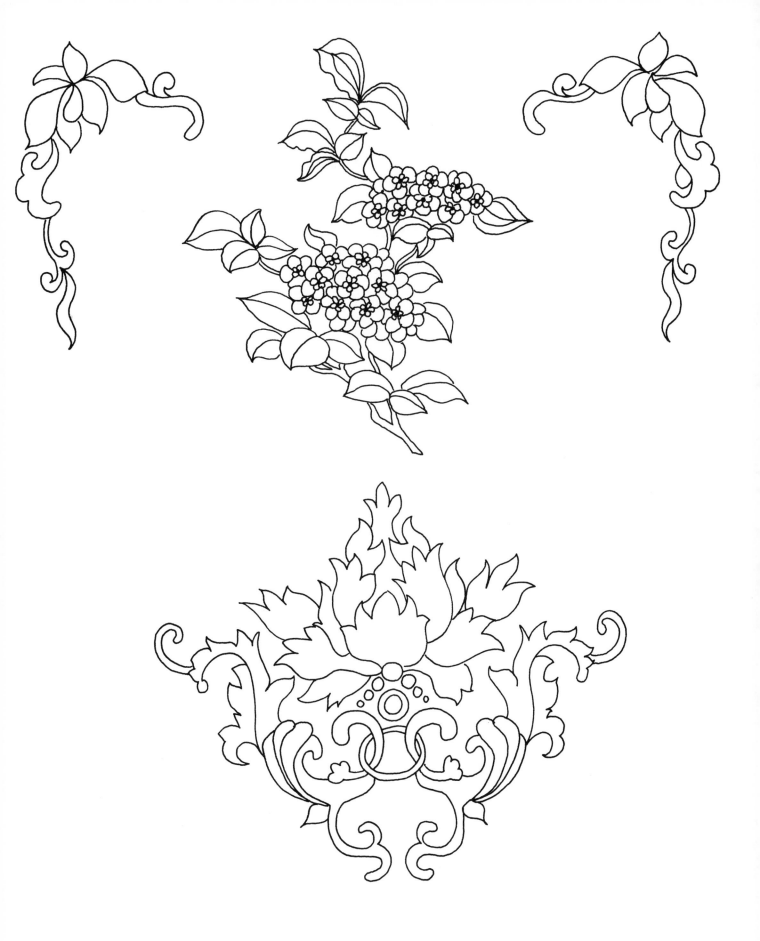

From 19th-century (Qing dynasty) textiles.

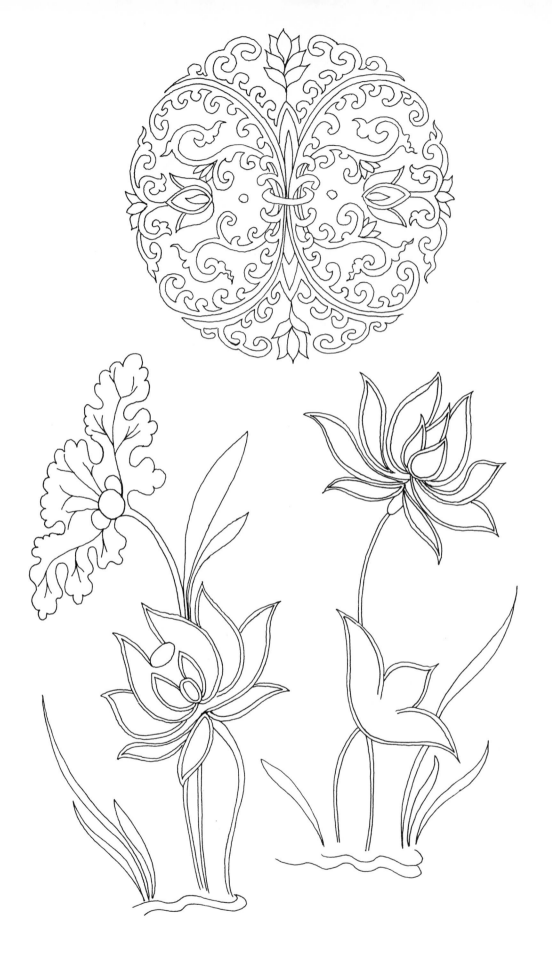

From Ming dynasty porcelain.

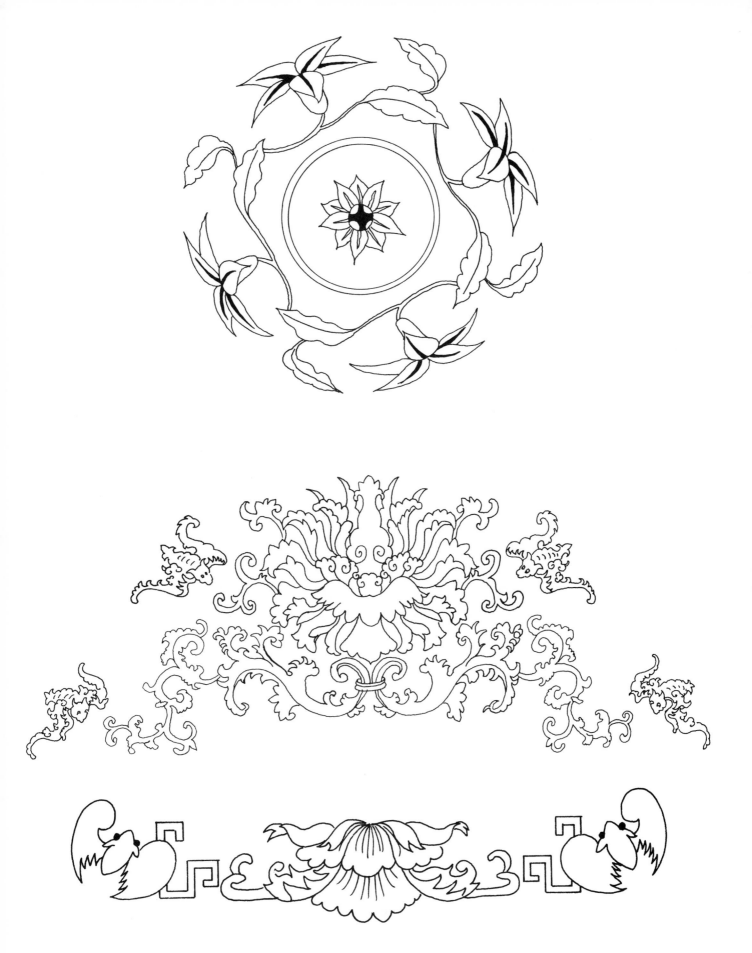

TOP: Motif from the Cheng hua period of the Ming dynasty.
CENTER & BOTTOM: From a 19th-century (Qing dynasty) fabric panel.

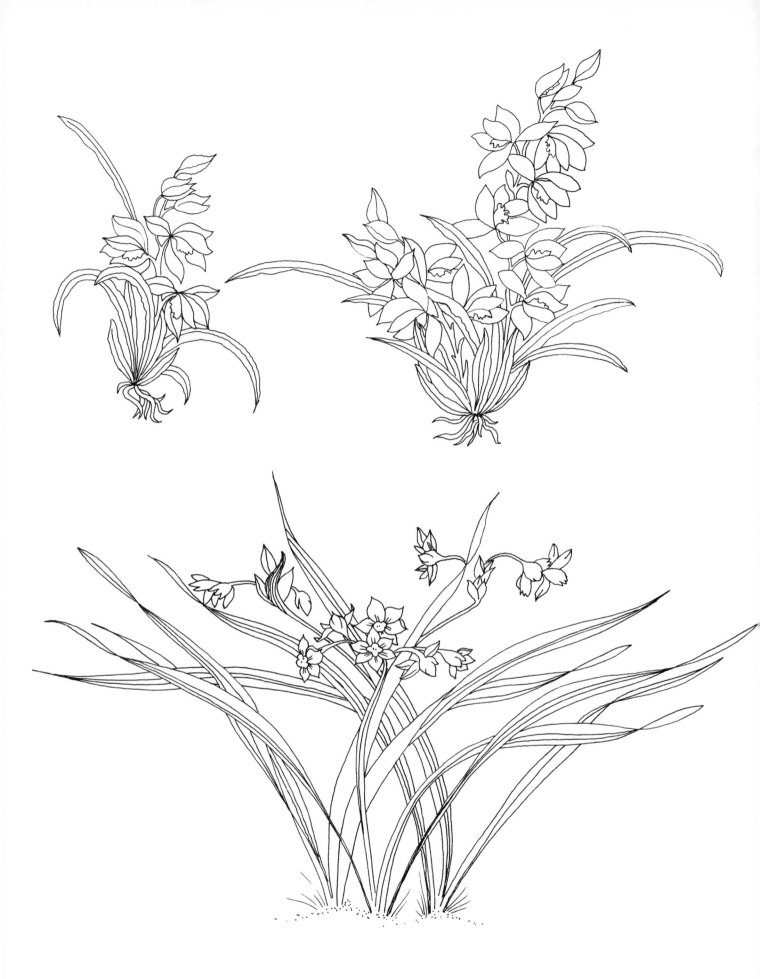

From a 19th-century (Qing dynasty) fabric panel.

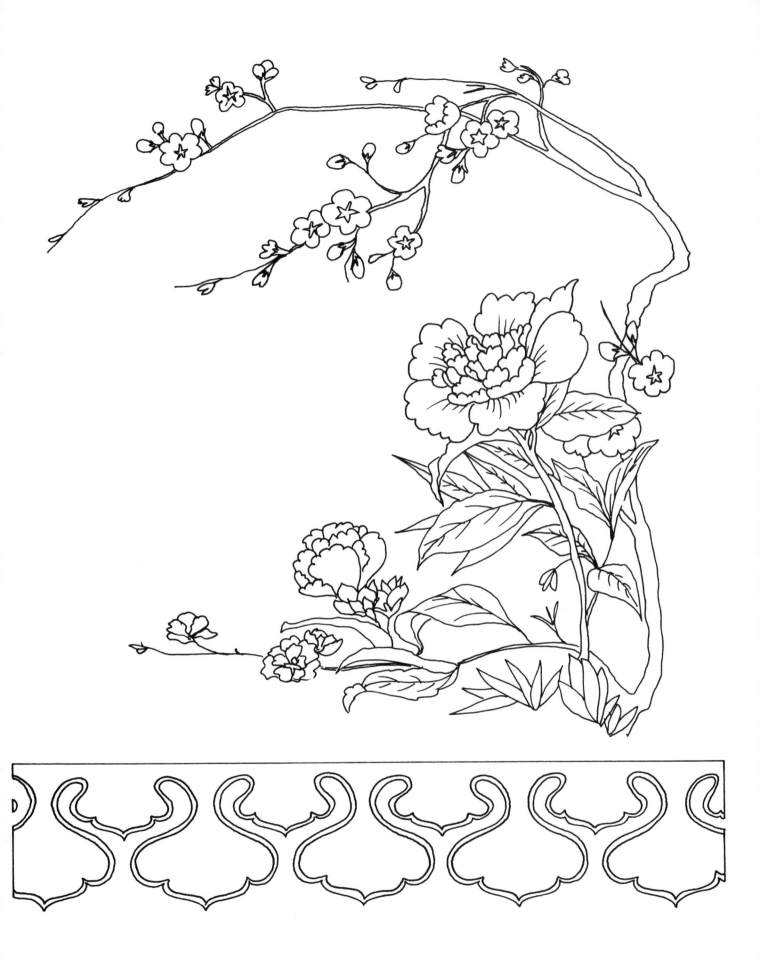

TOP: From Ming dynasty enamelware: BOTTOM: From a 19th-century (Qing dynasty) textile.

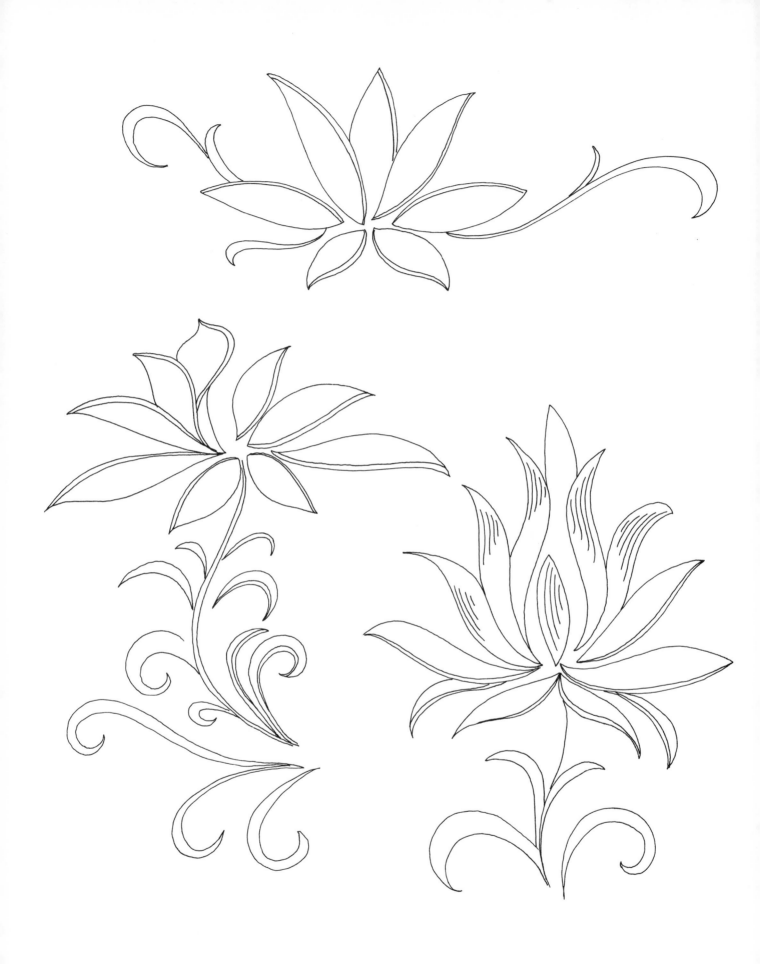

Lotus motifs from Song dynasty ceramics.

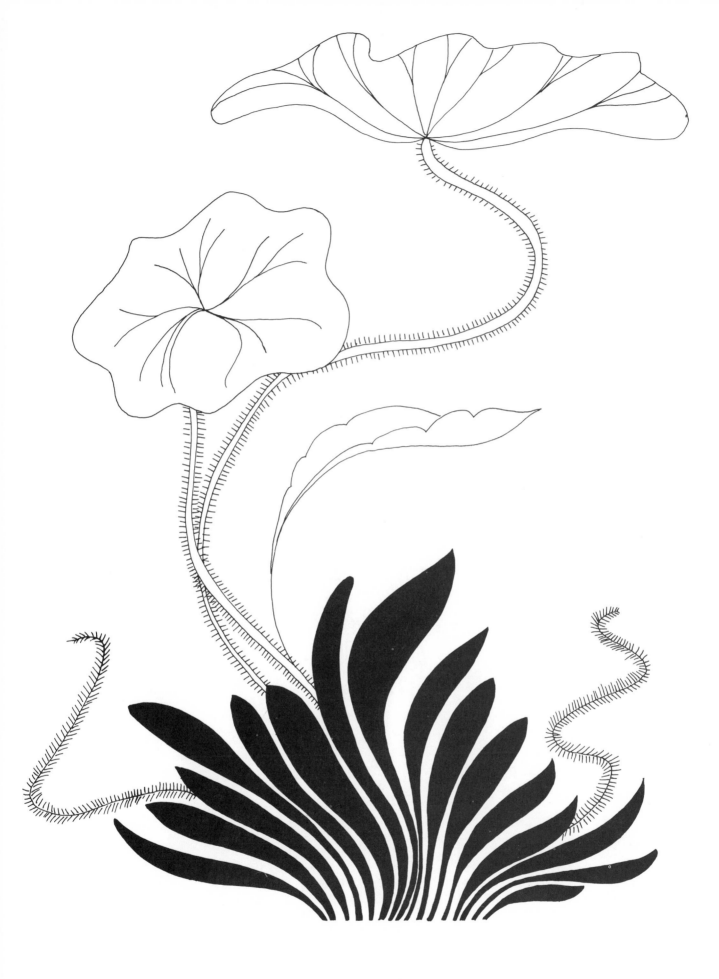

Lotus and water weed from a Ming dynasty porcelain.

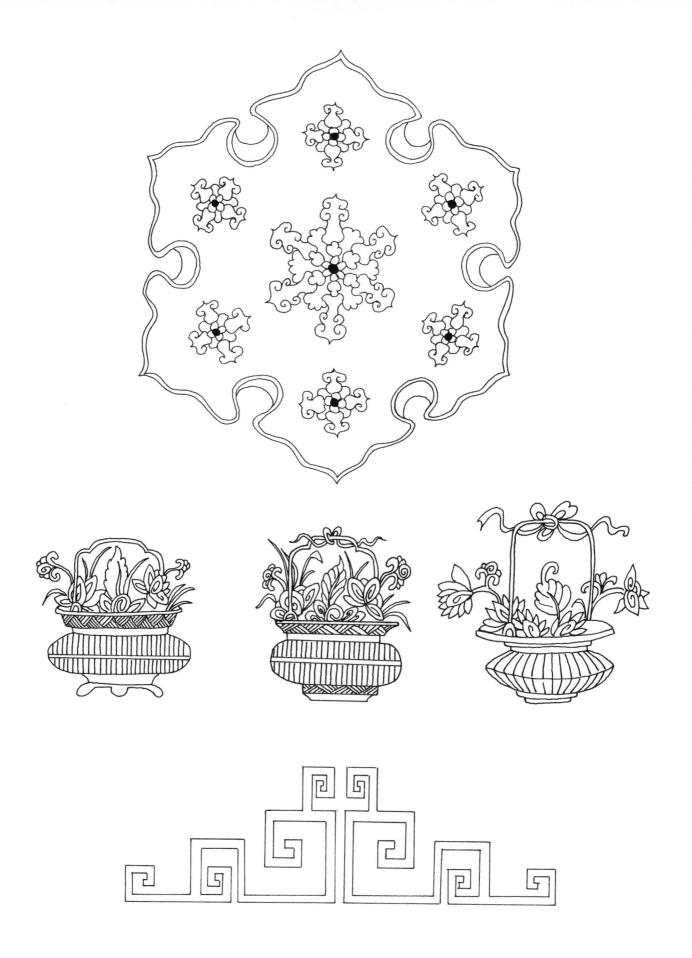

TOP: From a Tang dynasty ceramic. CENTER: Motifs from porcelain of the Kang xi period of the Qing dynasty.
BOTTOM: From a 19th-century (Qing dynasty) textile.

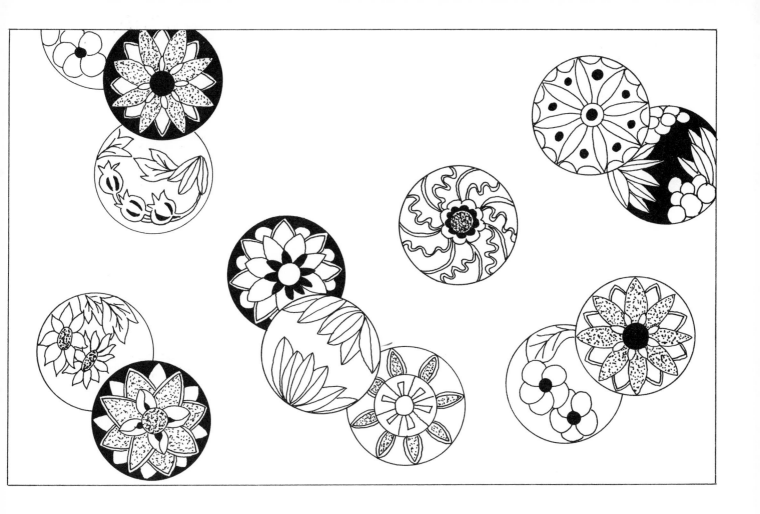

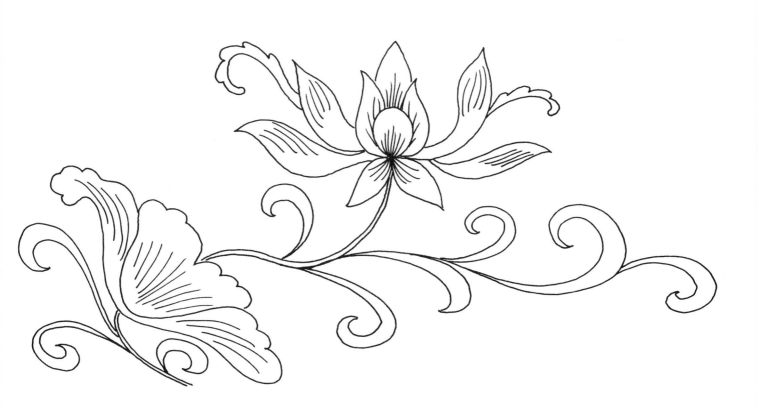

TOP: From a Ming dynasty fabric. BOTTOM: From a Song dynasty porcelain.

15

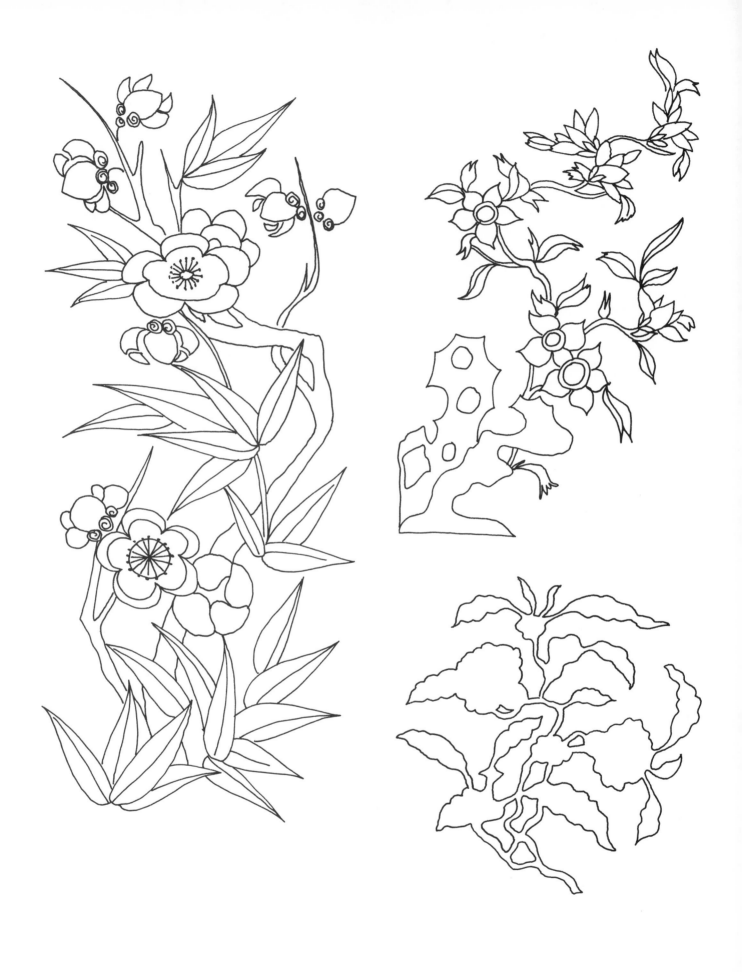

LEFT & UPPER RIGHT: From 19th-century (Qing dynasty) textiles. LOWER RIGHT: From a Ming dynasty porcelain.

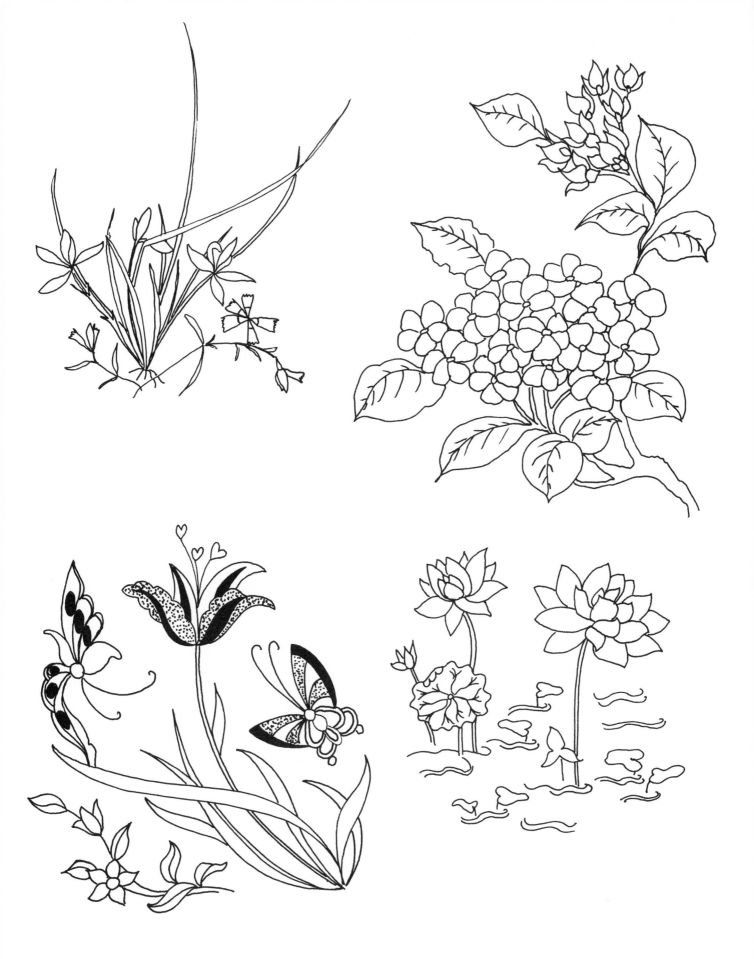

UPPER & LOWER LEFT, & UPPER RIGHT: From 19th-century (Qing dynasty) textiles. LOWER RIGHT: From a porcelain of the Qian long period of the Qing dynasty.

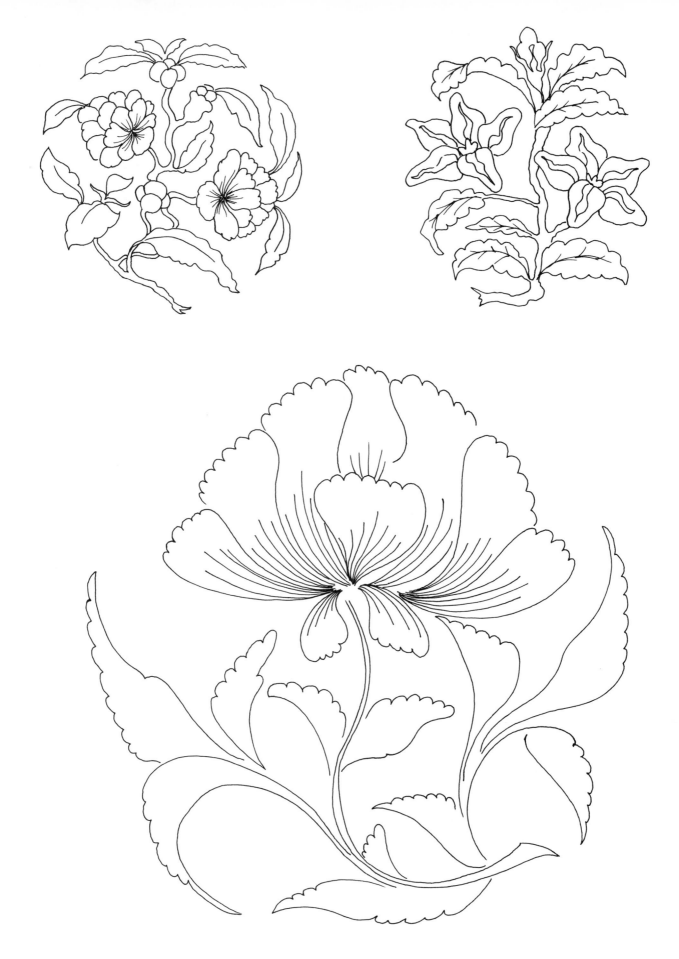

TOP LEFT: Peony branch from a porcelain of the Zheng de period of the Ming dynasty. TOP RIGHT: From a porcelain of the Hong zhi period of the Ming dynasty. BOTTOM: Peony blossom from a Northern Song dynasty porcelain.

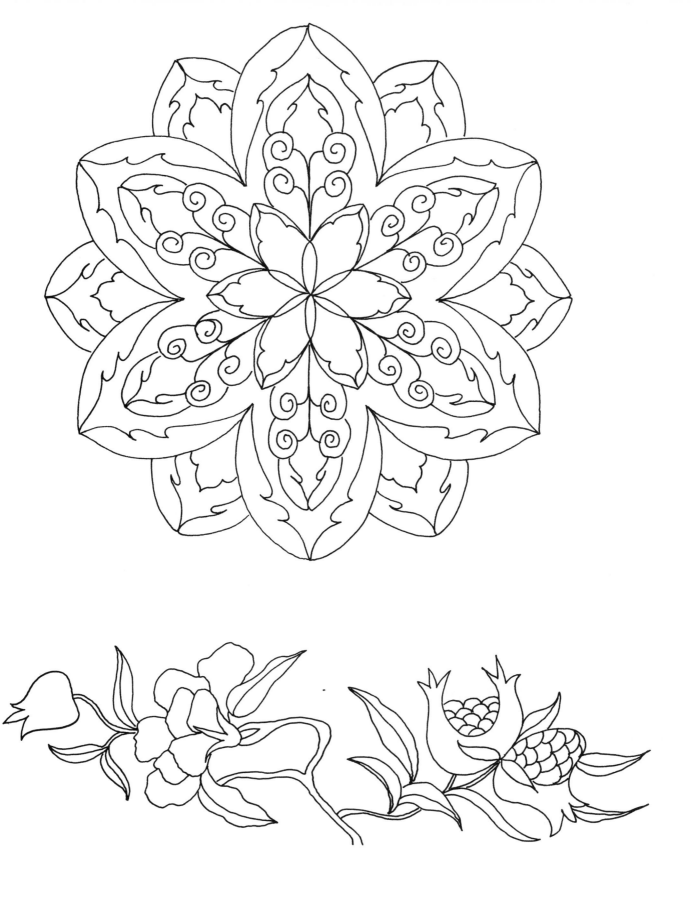

From 19th-century (Qing dynasty) textiles.

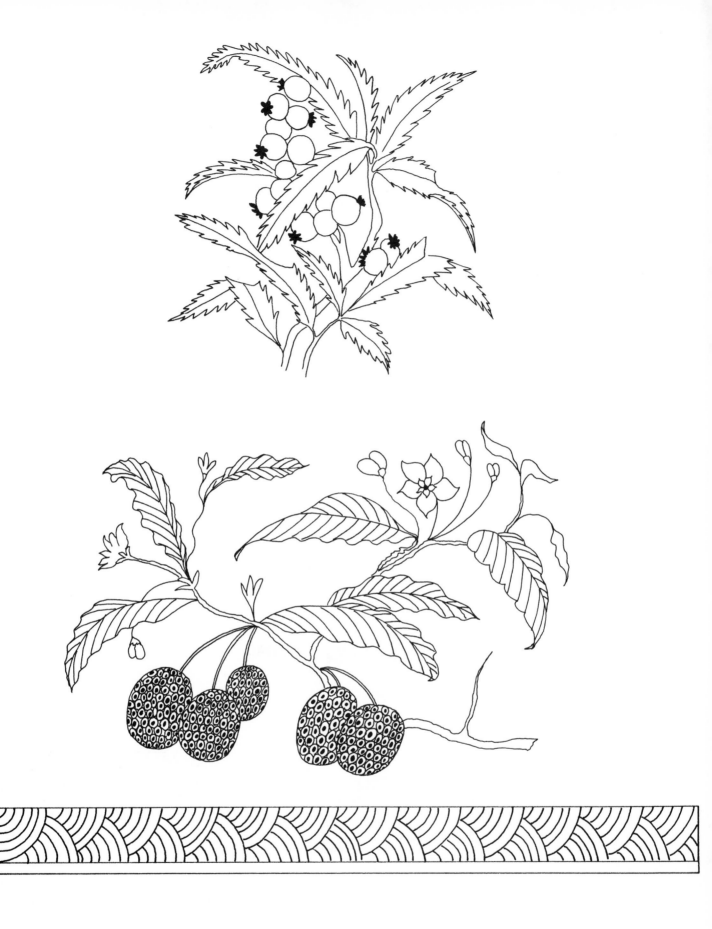

TOP: Loquat plant from a porcelain of the Xuan de period of the Ming dynasty. CENTER: Ming dynasty motif.
BOTTOM: From an early Ming dynasty porcelain.

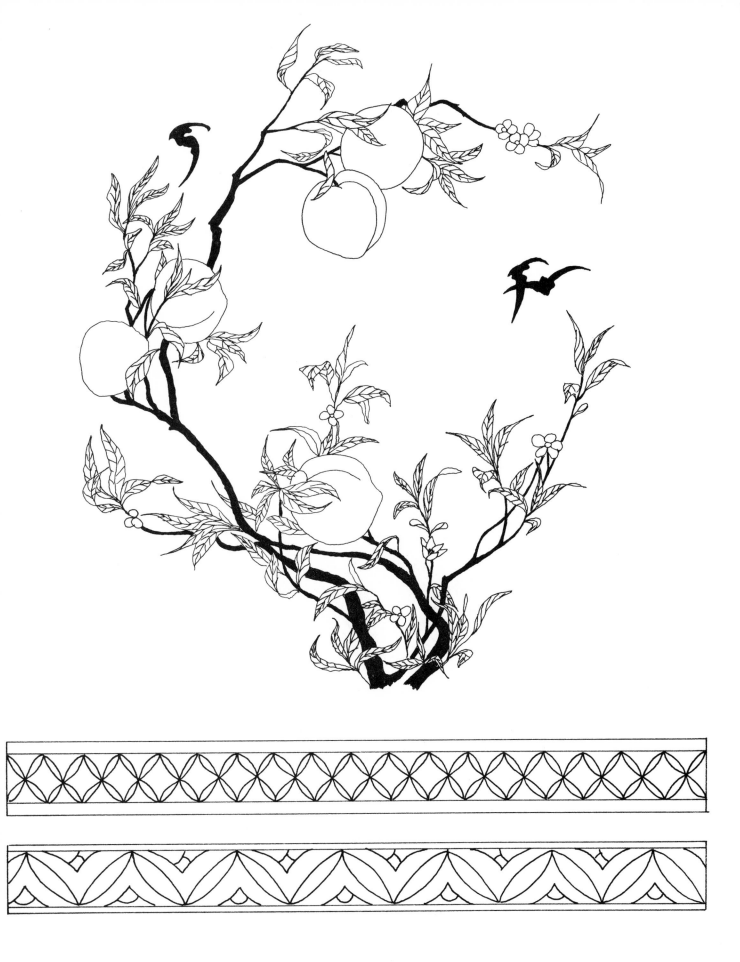

TOP: Peach bough from a porcelain of the Yong zheng period of the Qing dynasty.
BOTTOM: Bands from 16th-century (Ming dynasty) porcelains.

21

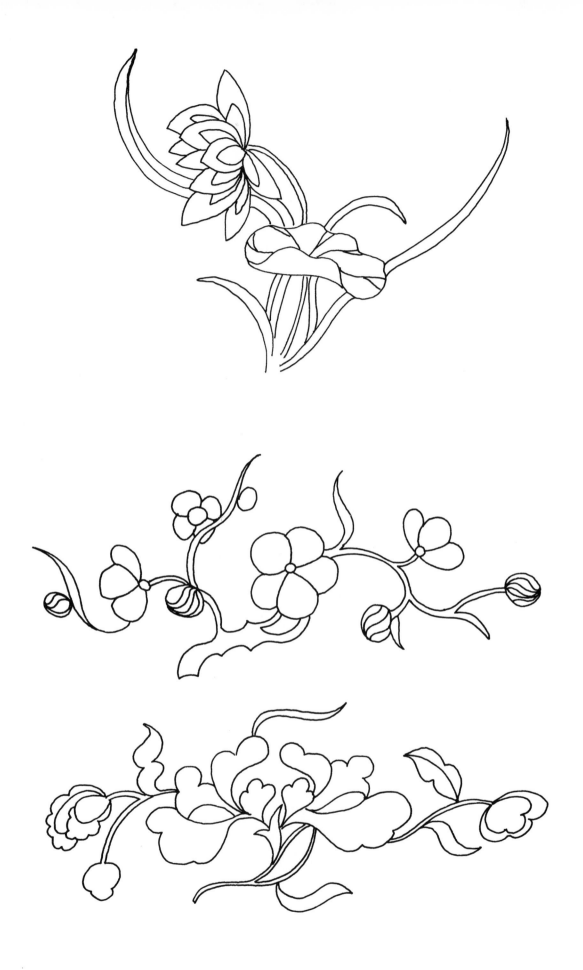

From 19th-century (Qing dynasty) embroideries.

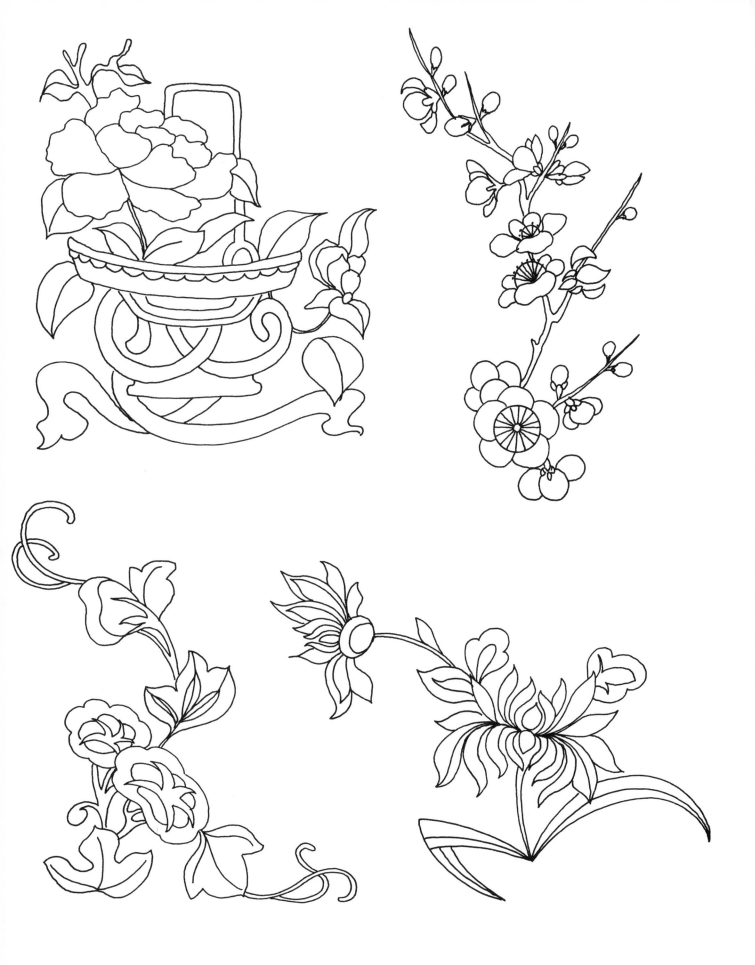

From 19th-century (Qing dynasty) textiles.

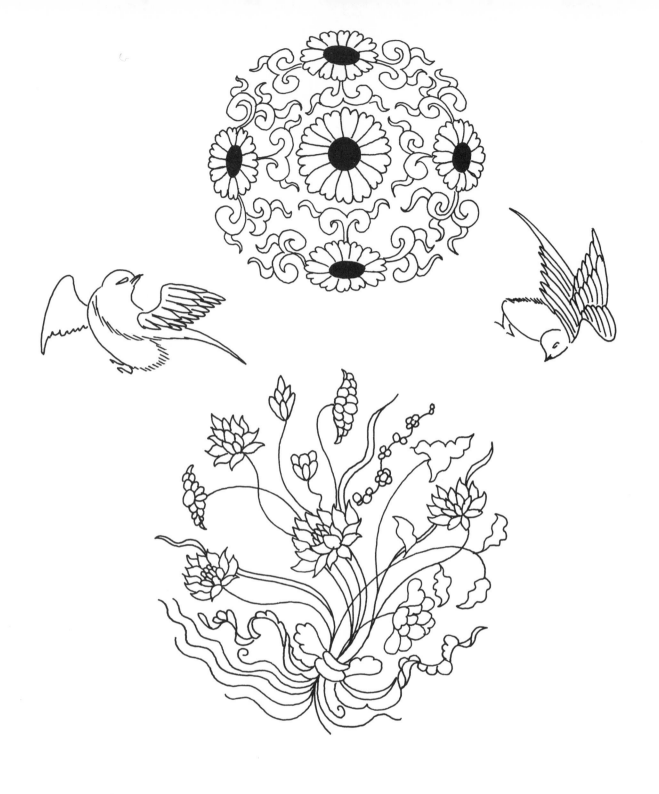

TOP: From a Qing dynasty porcelain. OTHERS: From Ming dynasty porcelains.

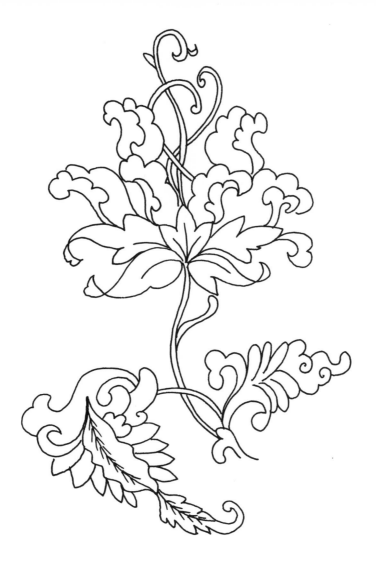

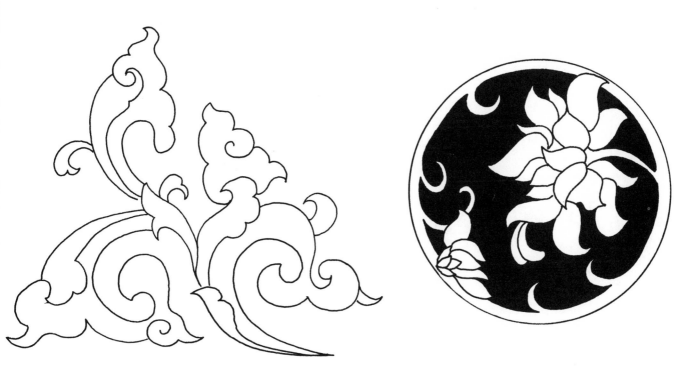

From Song dynasty porcelains.

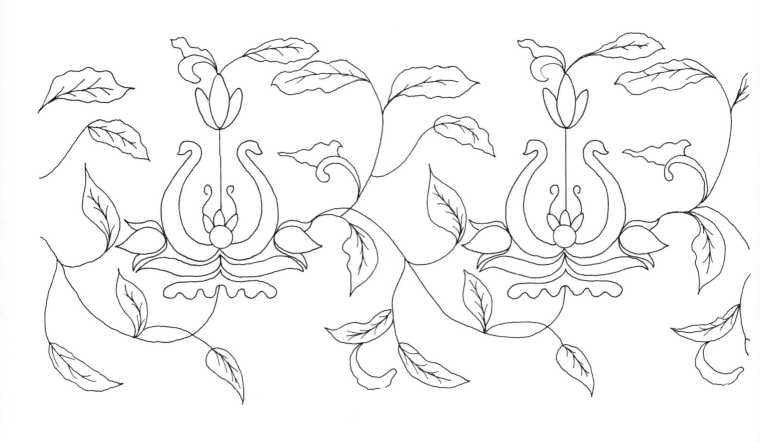

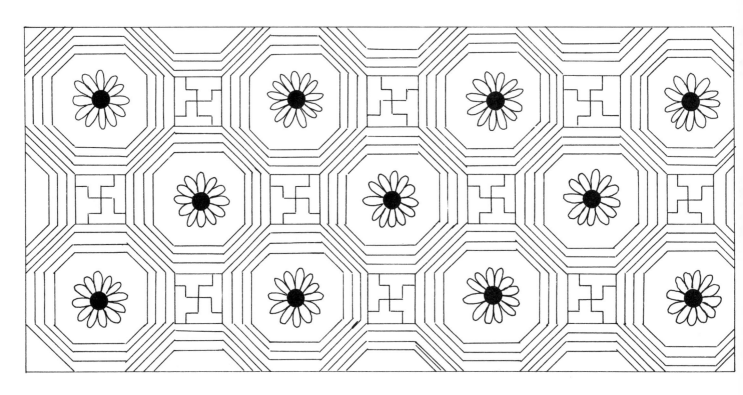

From porcelains of the Kang xi period of the Qing dynasty.

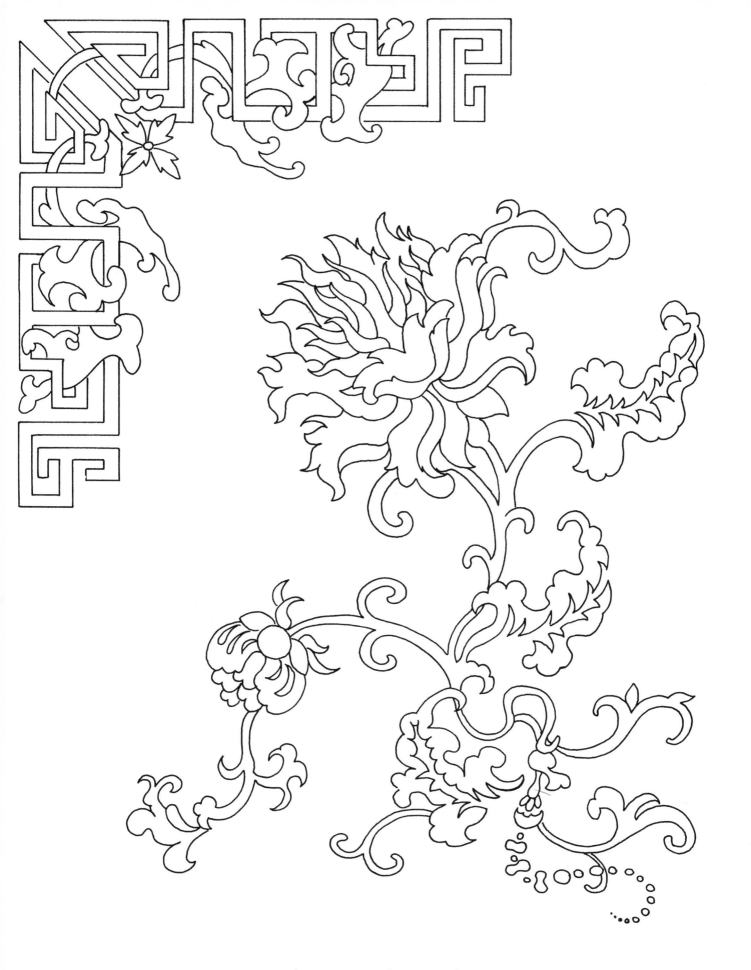

From 19th-century (Qing dynasty) textiles.

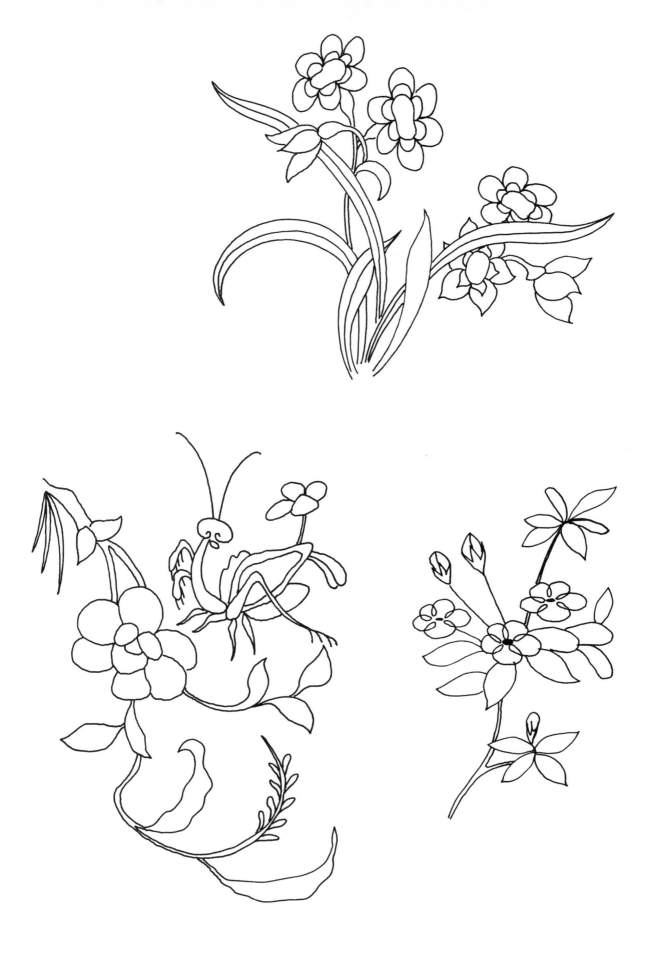

From 19th-century (Qing dynasty) embroideries.

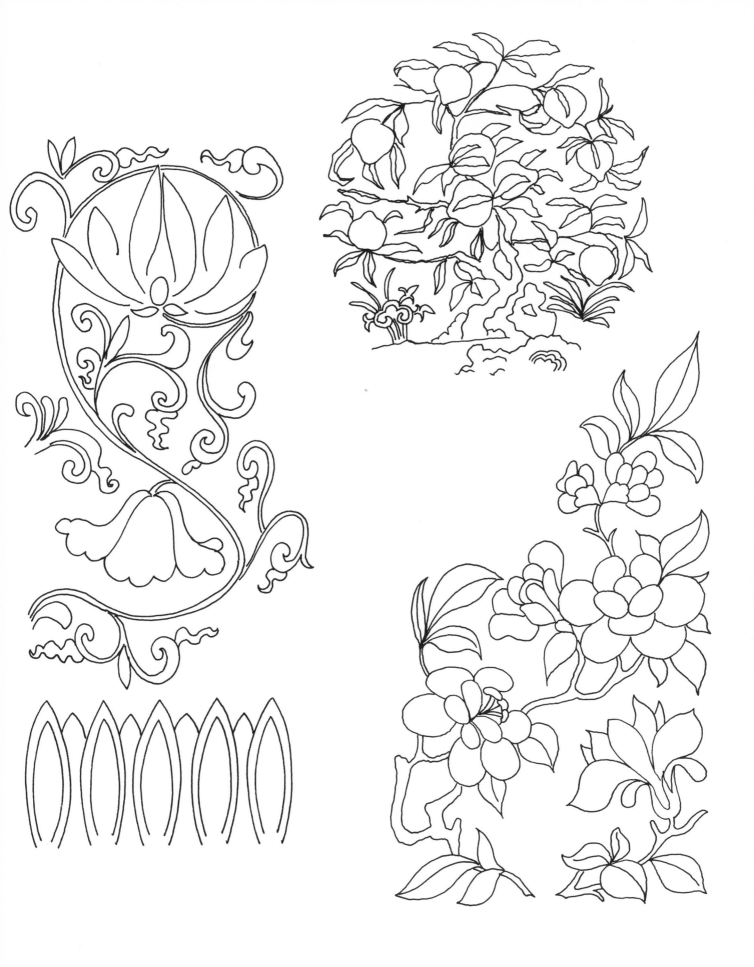

From 19th-century (Qing dynasty) textiles.

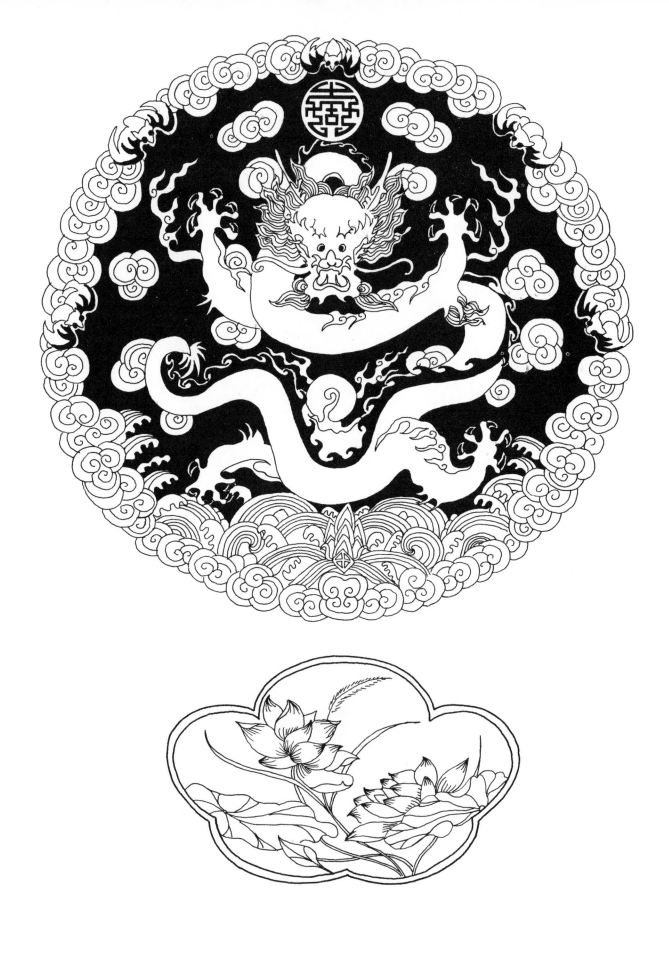

TOP: From a Qing dynasty embroidered dragon badge. BOTTOM: From a Qing dynasty porcelain.

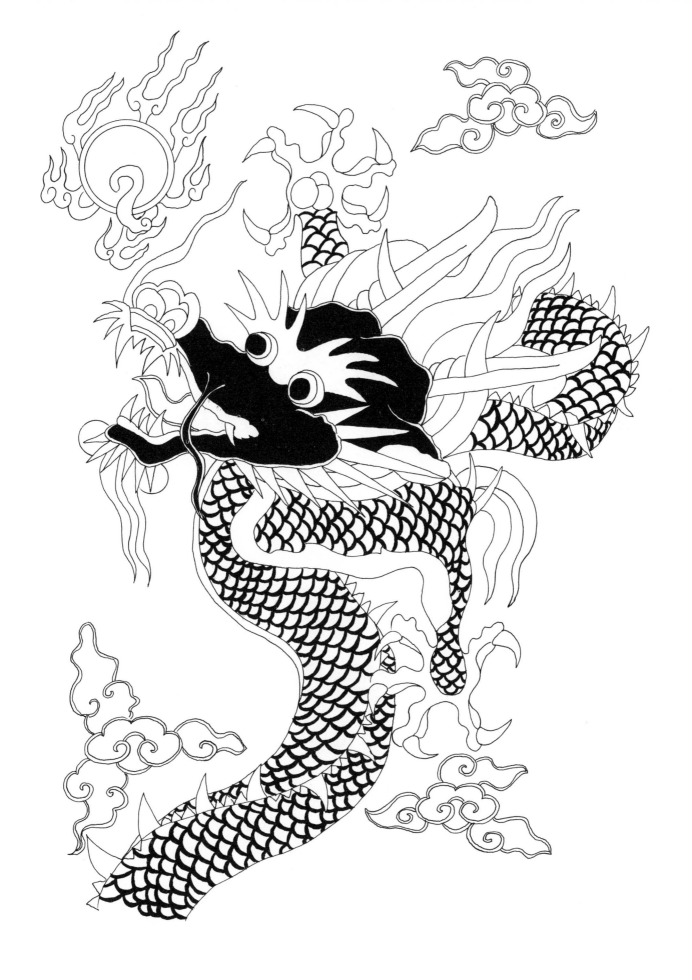

Dragon from a Qing dynasty embroidery.

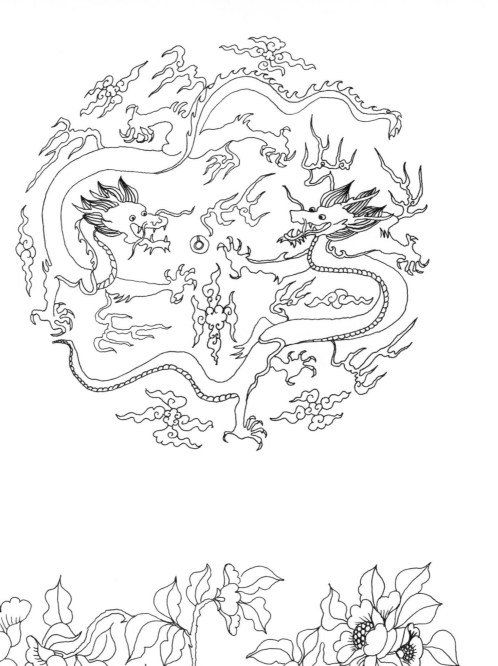

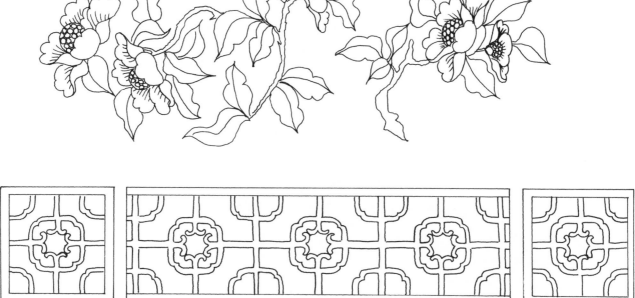

TOP: Dragons from a porcelain of the Kang xi period of the Qing dynasty. CENTER: Motif from lacquer.
BOTTOM: From a 19th-century (Qing dynasty) bedstead.

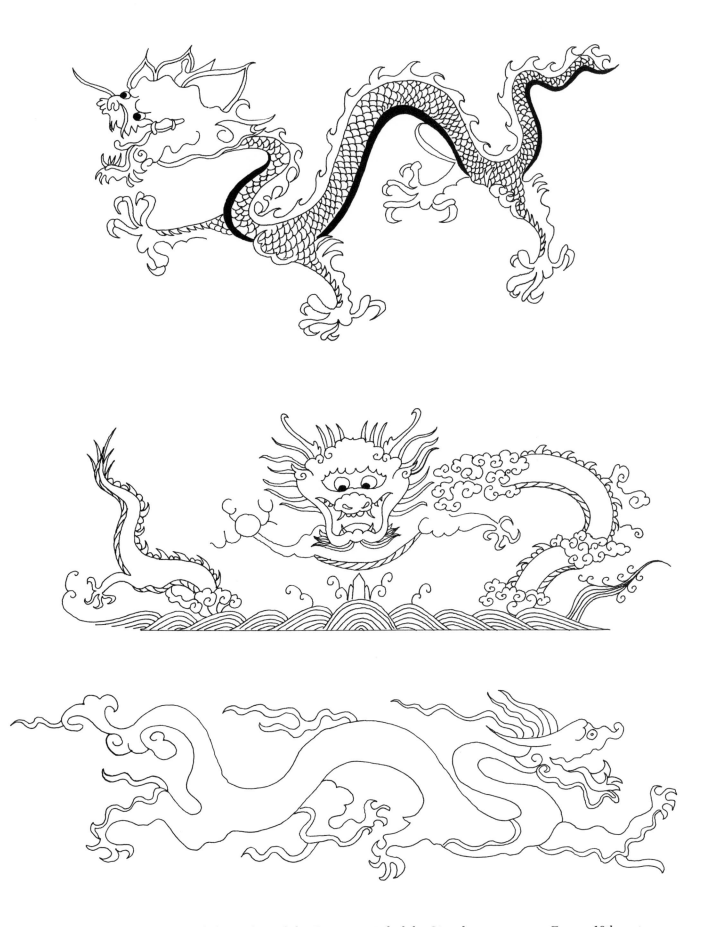

Dragons. TOP: From an enameled porcelain of the Kang xi period of the Qing dynasty. CENTER: From a 19th-century (Qing dynasty) textile. BOTTOM: From a 19th-century (Qing dynasty) porcelain.

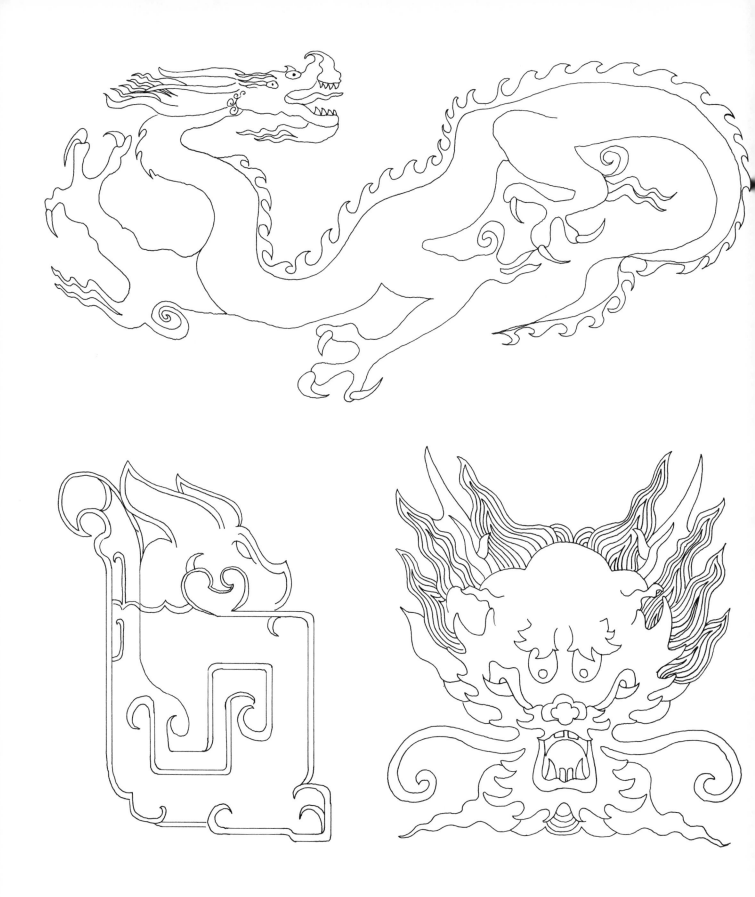

TOP: Dragon, early Ming dynasty. BOTTOM LEFT: From a Zhou dynasty jade plaque.
BOTTOM RIGHT: From a Ming dynasty embroidery.

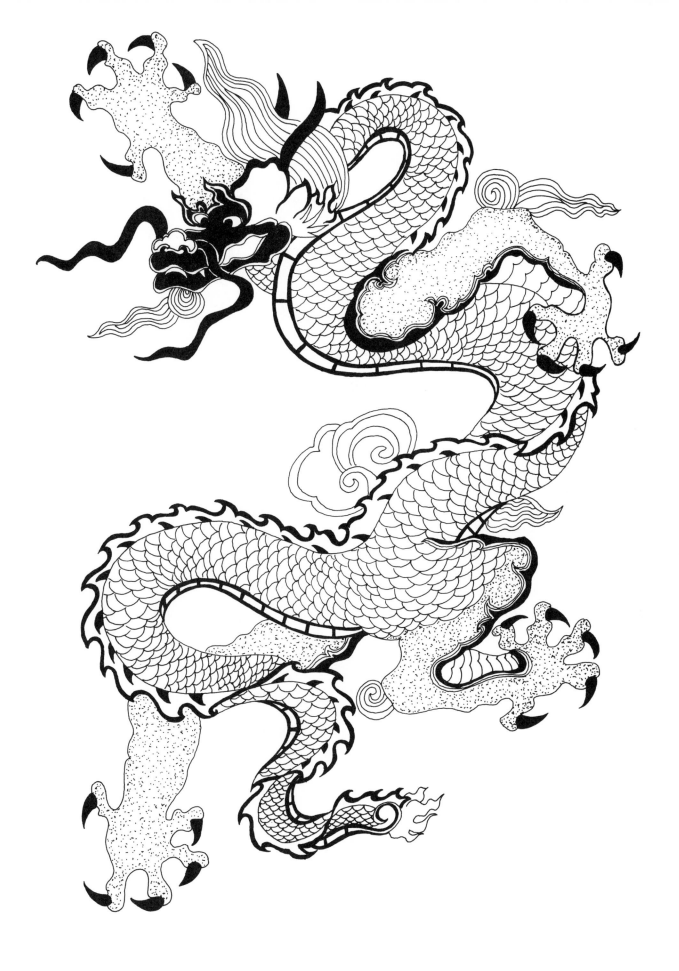

Five-clawed imperial dragon from an embroidered court robe of the late Ming dynasty.

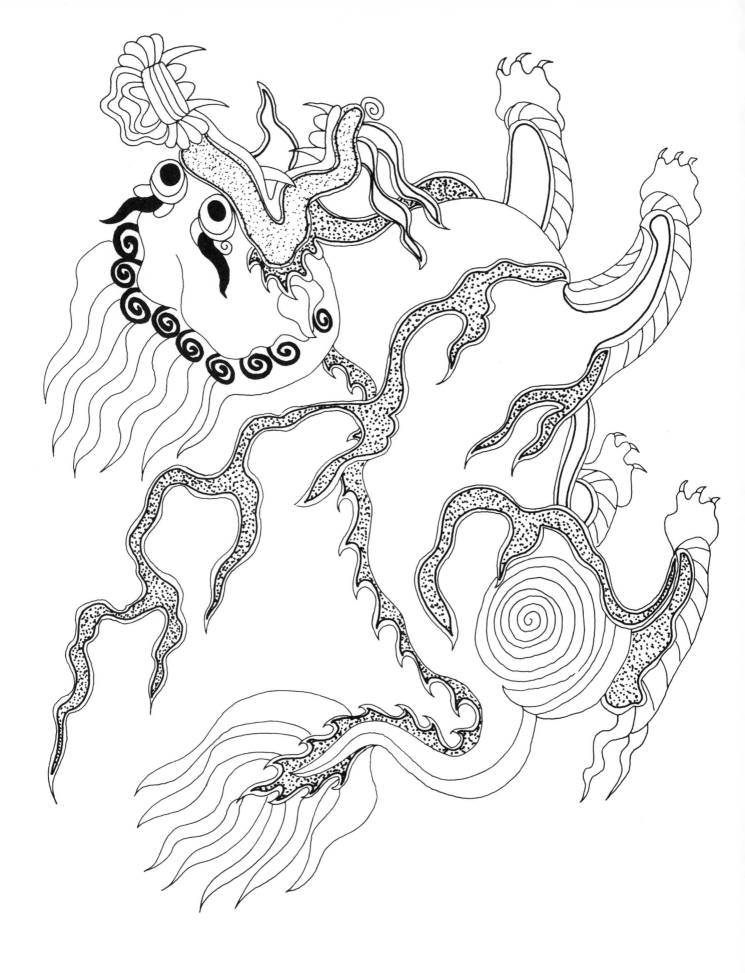

Fantastic lion from a Ming dynasty embroidery.

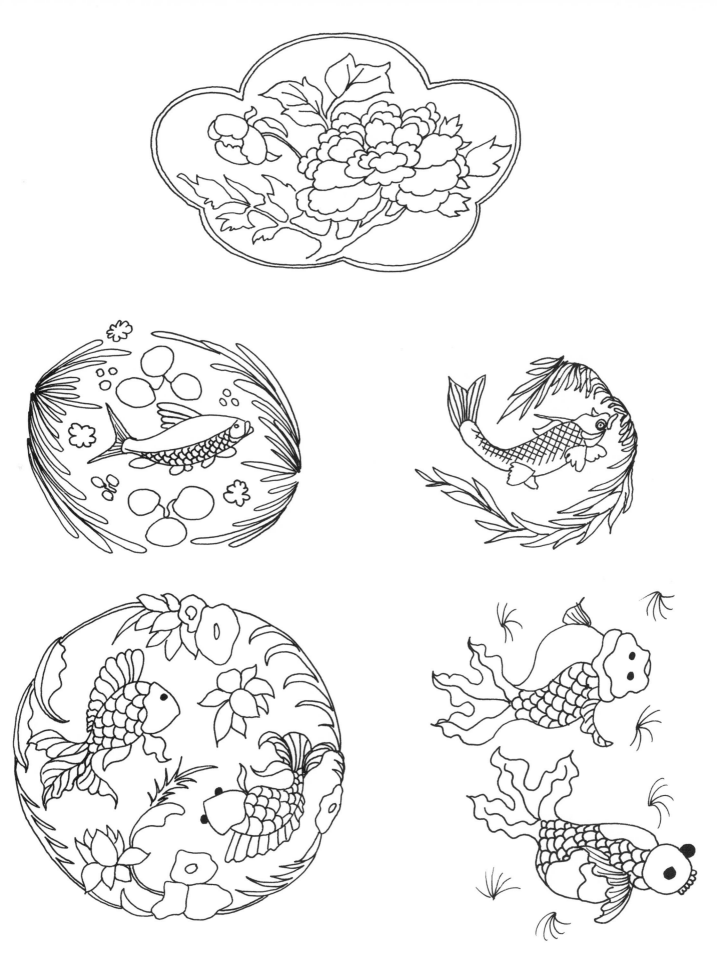

TOP: From a Yuan dynasty porcelain. CENTER LEFT: Goldfish from Yuan dynasty stoneware.
OTHERS: Goldfish from 19th-century (Qing dynasty) textiles.

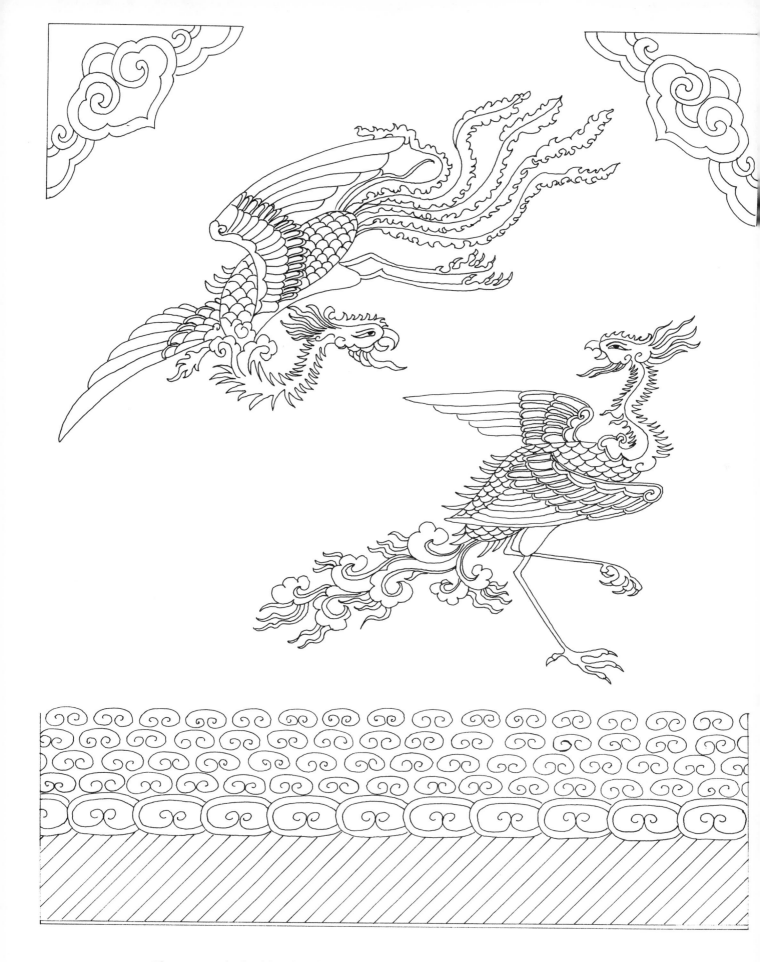

TOP: Phoenixes with cloud brackets from a late Ming dynasty tapestry hanging. BOTTOM: Wave motif from a late Ming dynasty embroidered court garment.

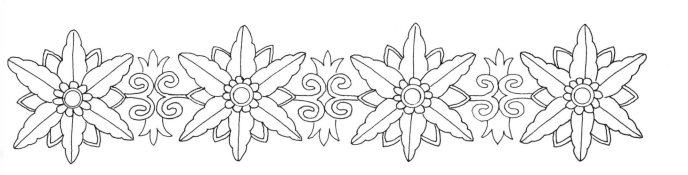

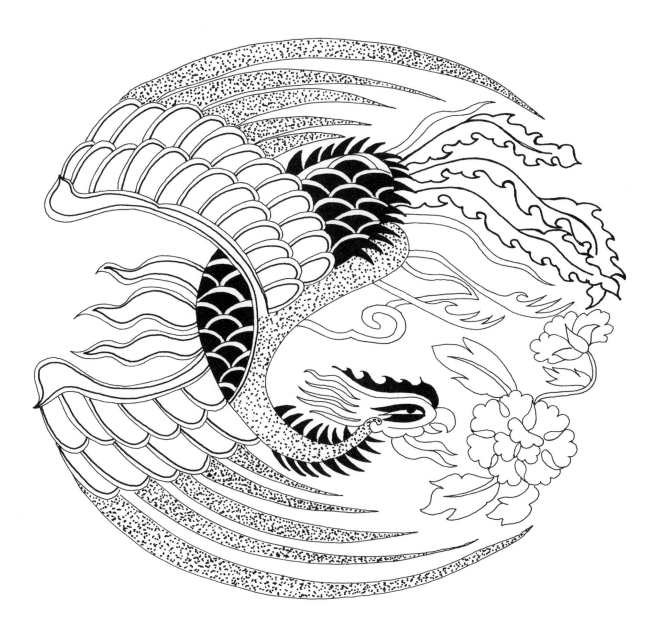

Phoenix and floral band from a 17th-century fabric panel.

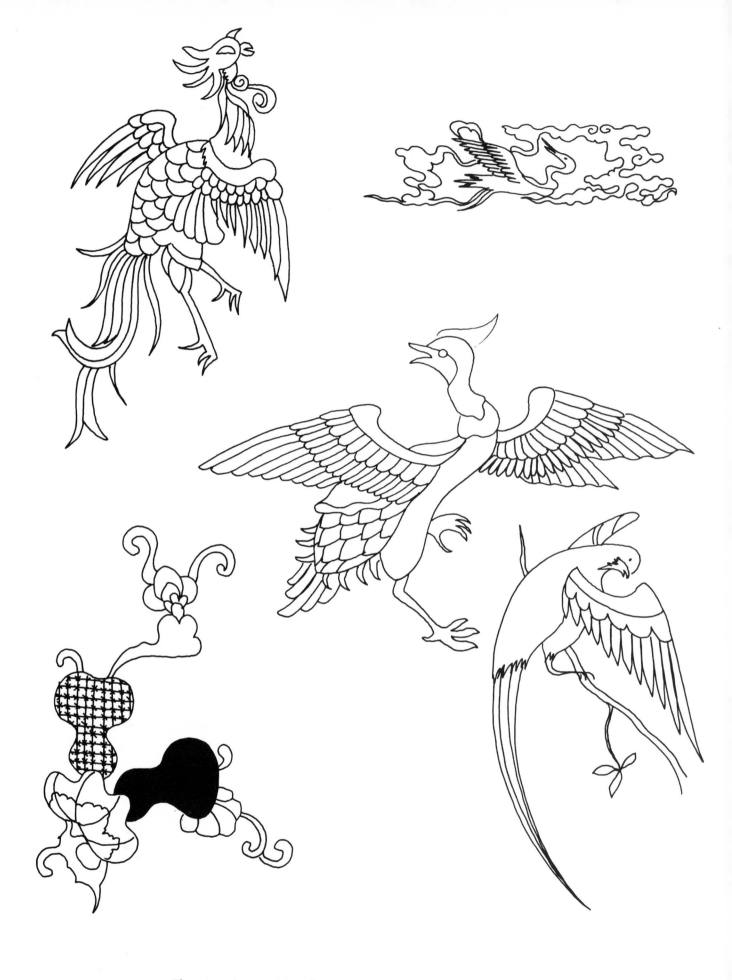

TOP, LEFT & RIGHT: Phoenix and crane, Ming dynasty. OTHERS: Birds from 19th-century (Qing dynasty) textiles.

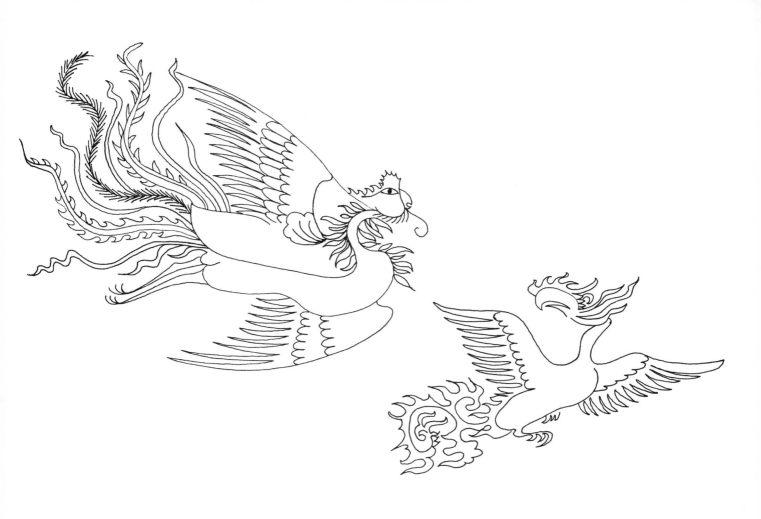

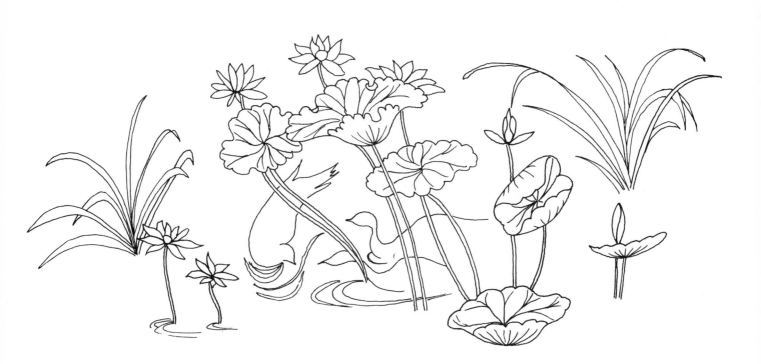

TOP LEFT: Phoenix from a porcelain of the Kang xi period of the Qing dynasty. TOP RIGHT: From a Yuan dynasty porcelain. BOTTOM: Aquatic birds from a Ming dynasty porcelain.

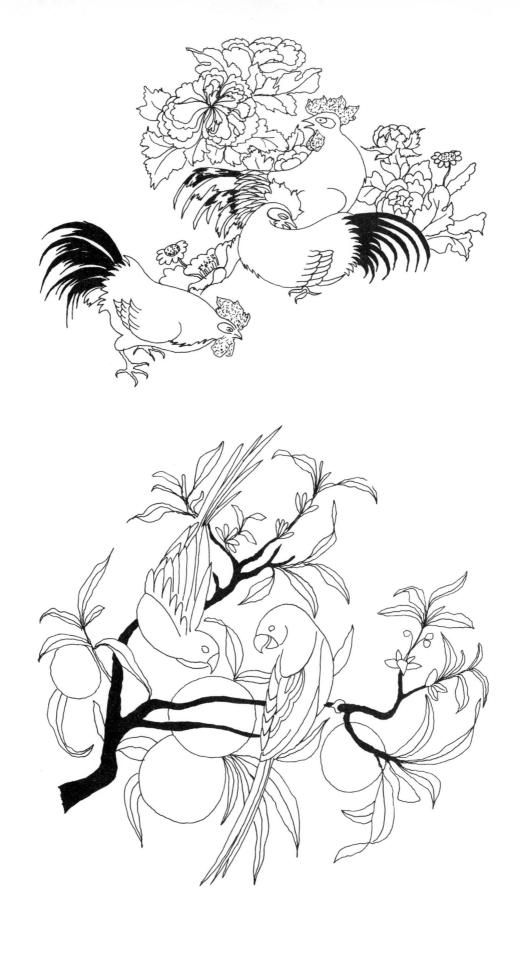

TOP: Chickens from Qing dynasty enamelware. BOTTOM: Parakeets from a porcelain of the Xuan de period of the Ming dynasty.

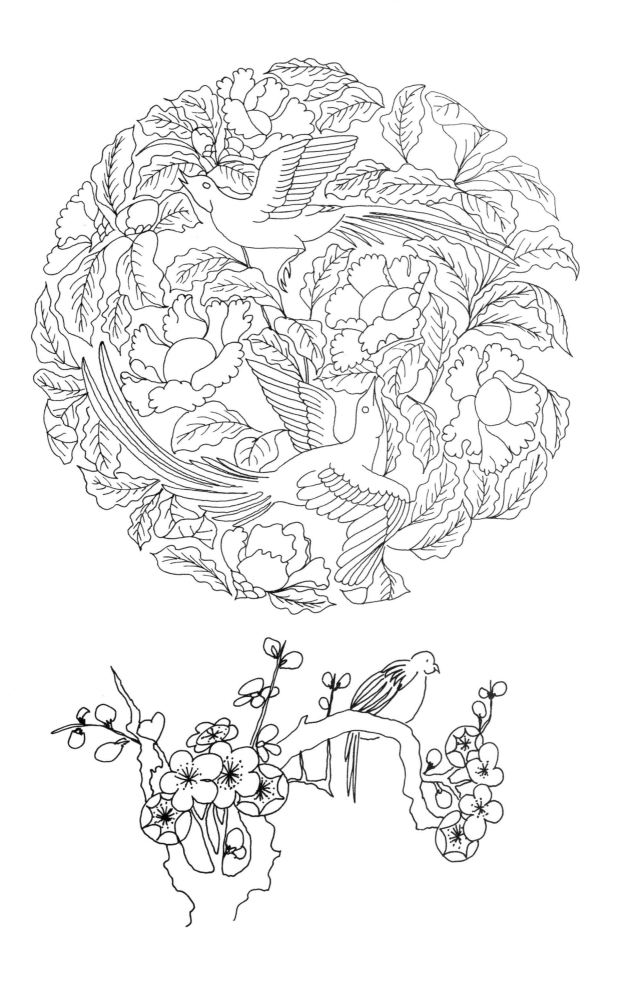

Birds. TOP: From a porcelain of the Kang xi period of the Qing dynasty. BOTTOM: From Ming lacquer.

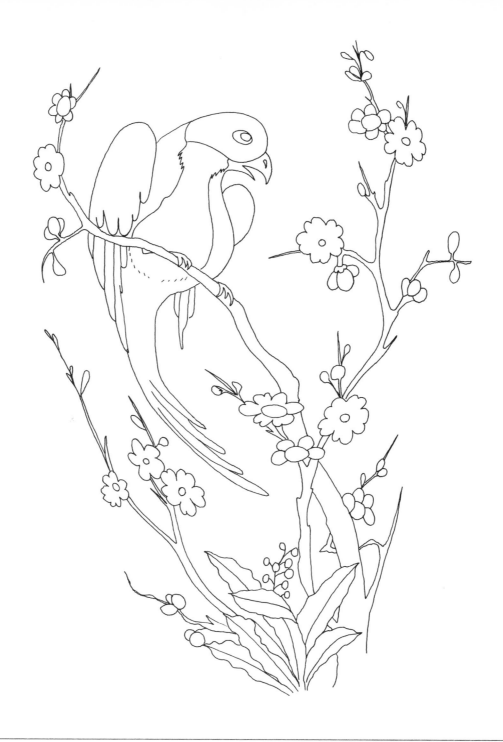

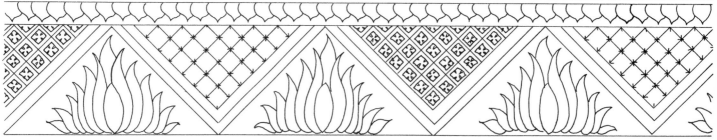

TOP: Parrot on a peach bough from a Qing dynasty ceramic. BOTTOM: From a porcelain of the Hong zhi period of the Ming dynasty.

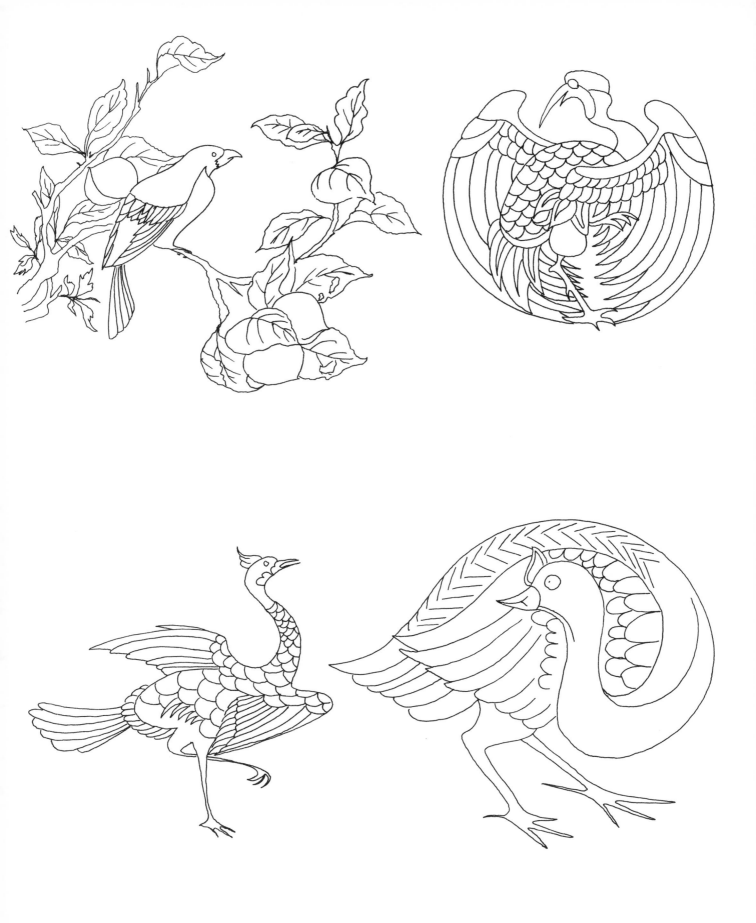

Birds. TOP LEFT: From a porcelain of the Kang xi period of the Qing dynasty. TOP RIGHT: Crane from a Ming dynasty embroidery. BOTTOM LEFT: From a Ming dynasty porcelain. BOTTOM RIGHT: From Tang dynasty pottery.

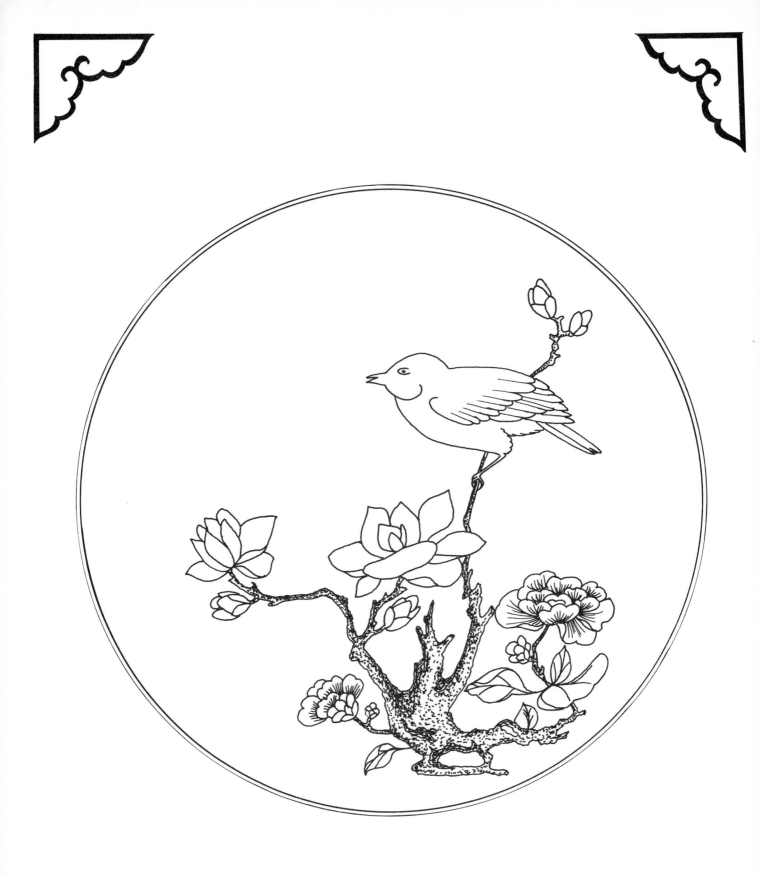

Bird from a Ming dynasty porcelain.

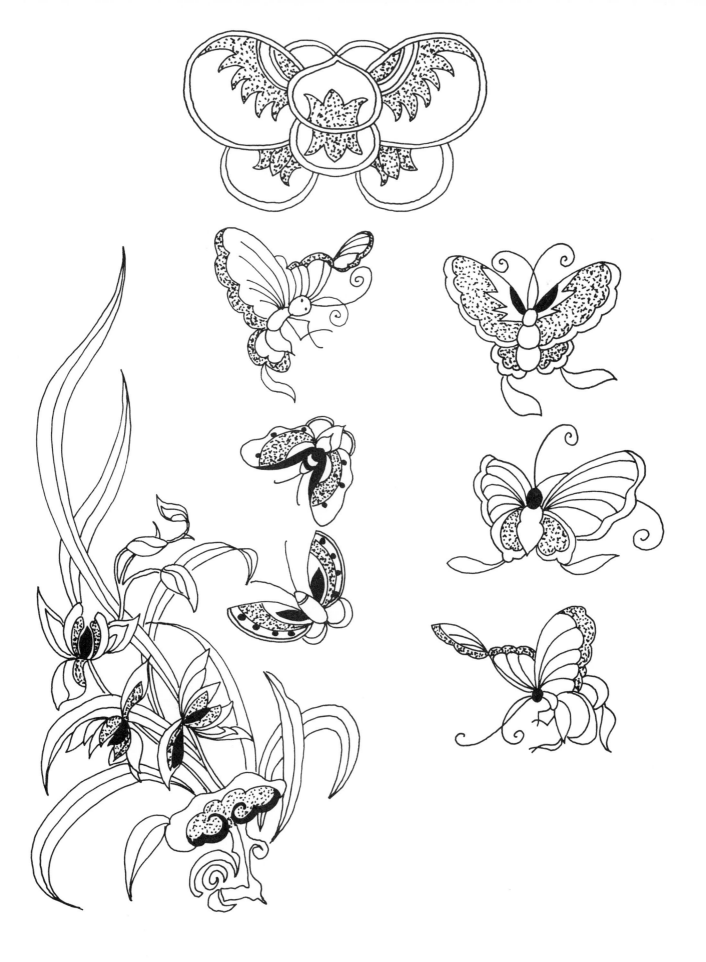

Butterflies from 19th-century (Qing dynasty) textiles.

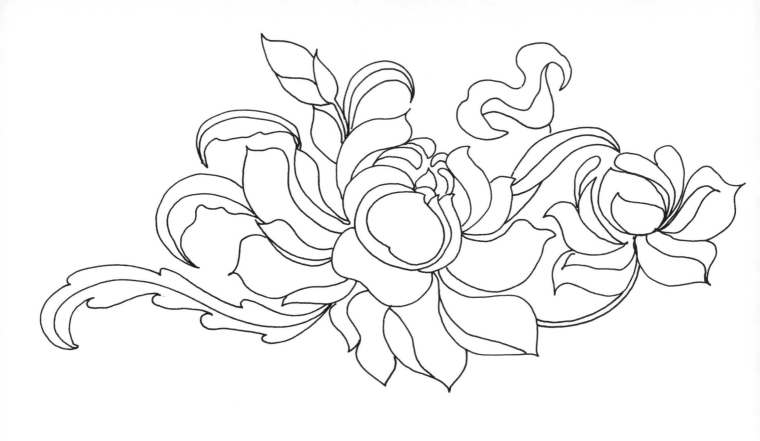

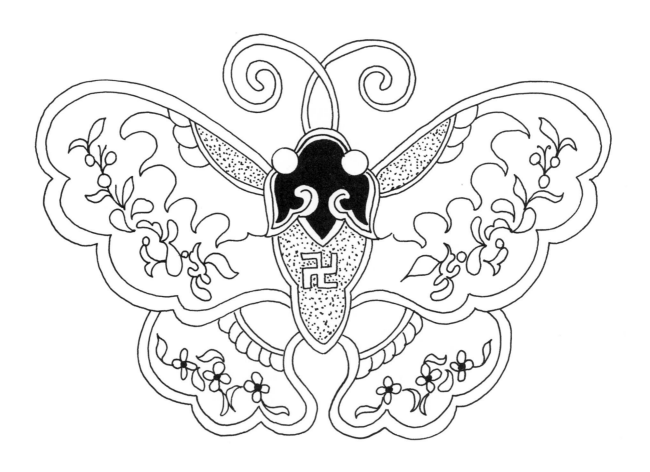

Flower and moth from 19th-century (Qing dynasty) textiles.

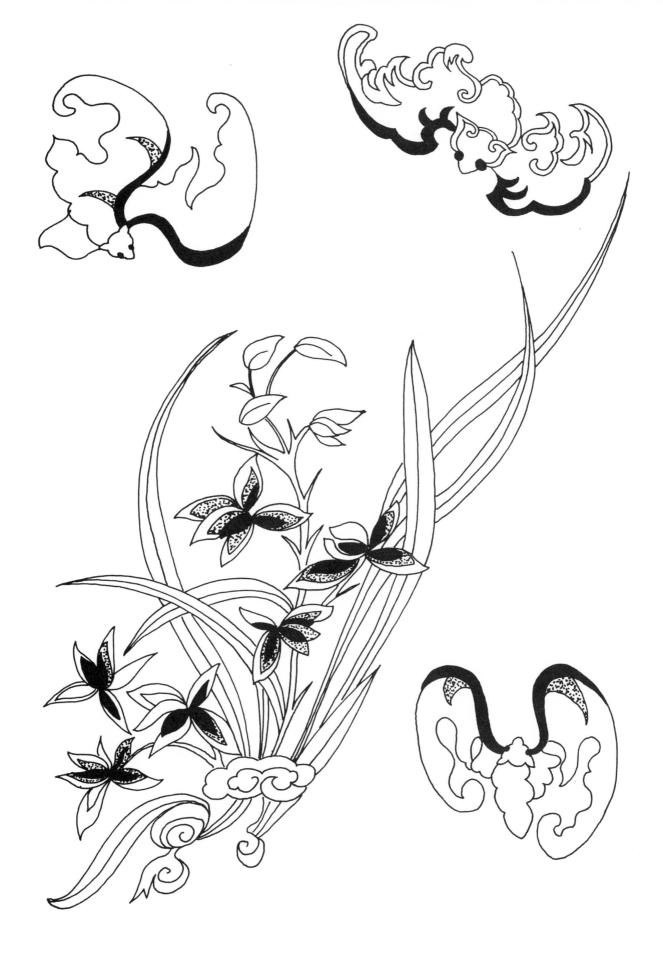

Bats and flowers from a 19th-century (Qing dynasty) textile.

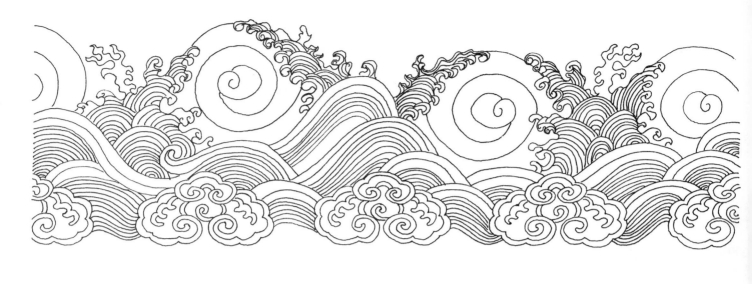

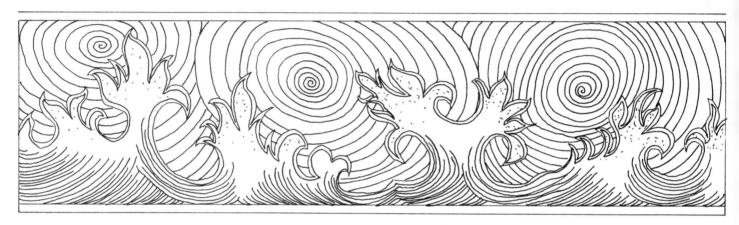

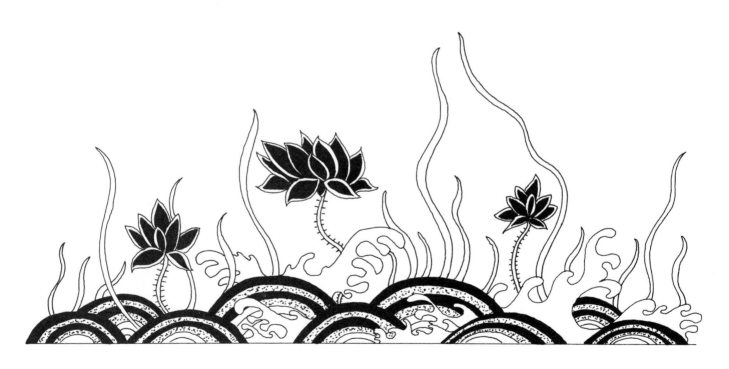

TOP & CENTER: Wave motifs from porcelain. BOTTOM: From a Ming dynasty porcelain.

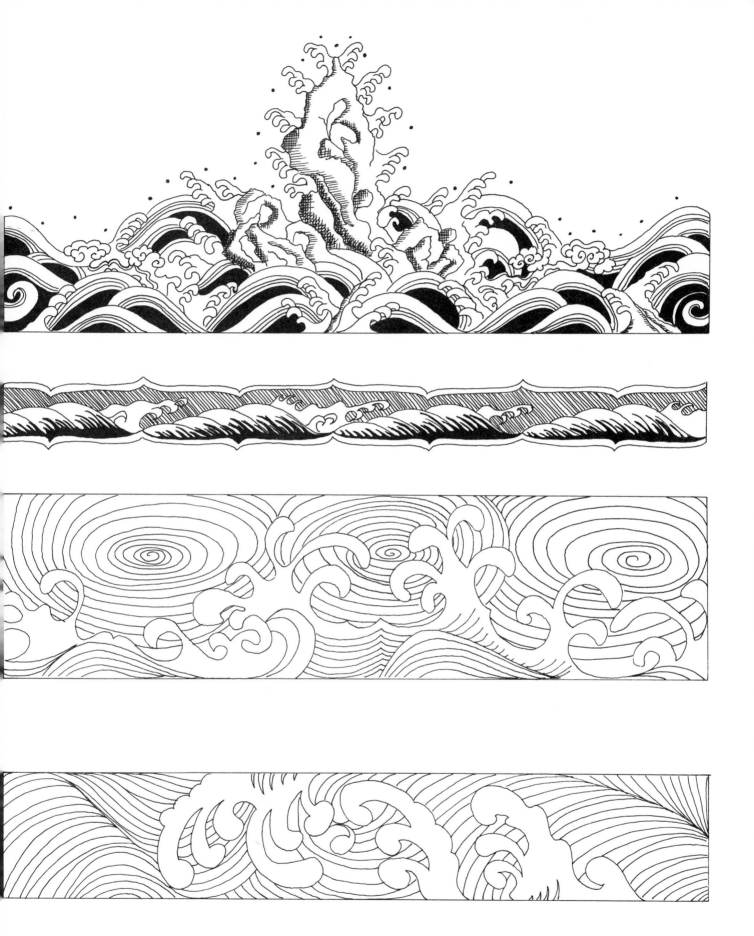

Wave motifs, Xuan de period of the Ming dynasty.

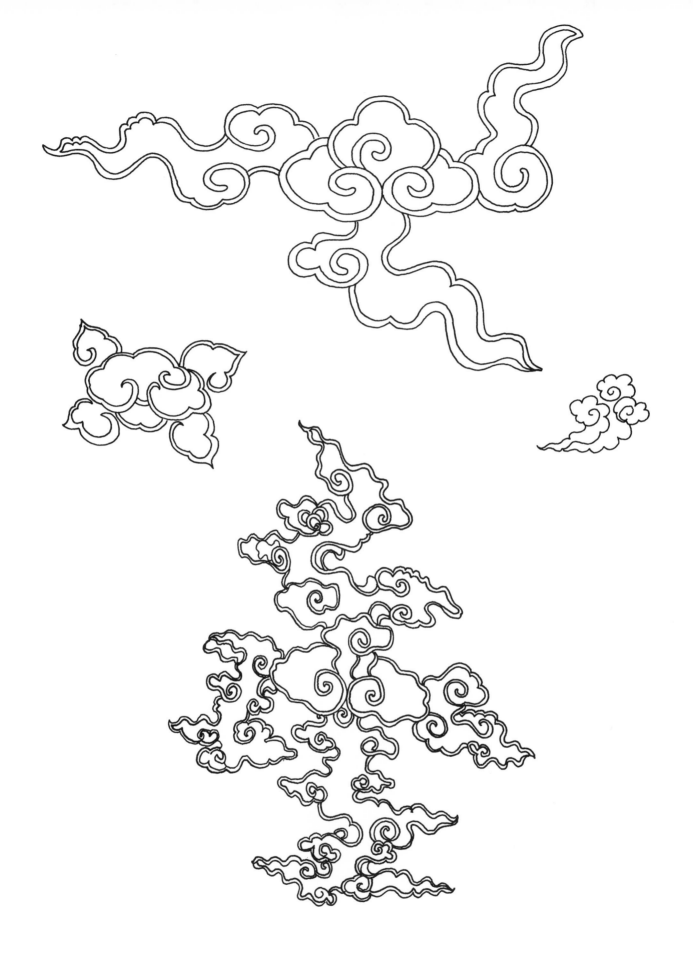

Cloud forms from porcelain and (bottom) a 19th-century (Qing dynasty) textile.

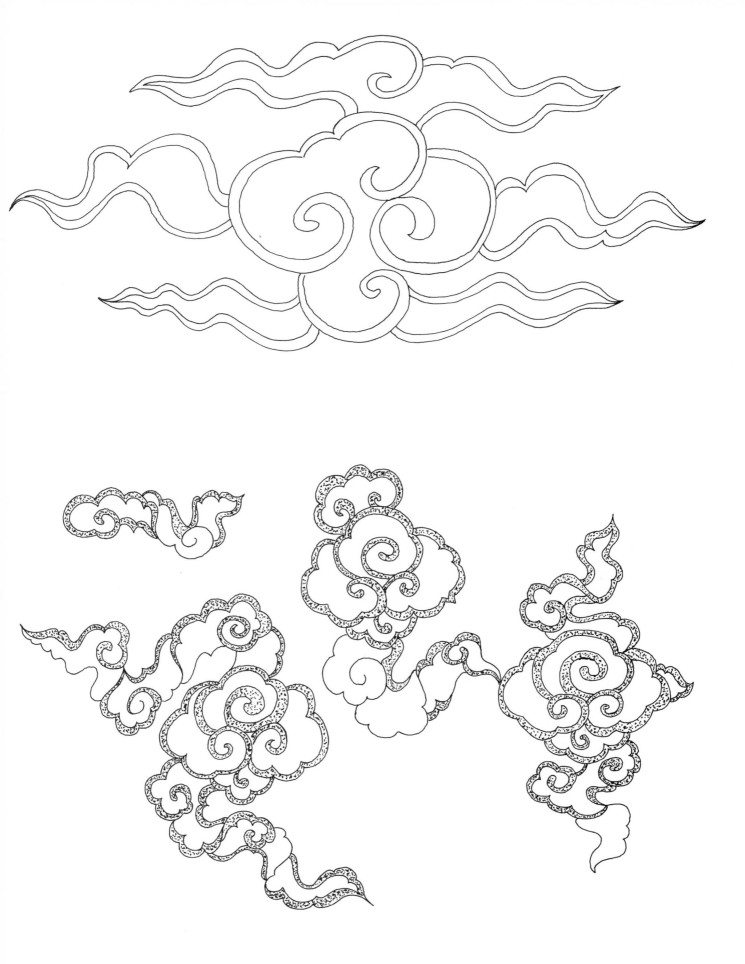

Cloud forms from ceramics of the Jia jing period of the Ming dynasty.

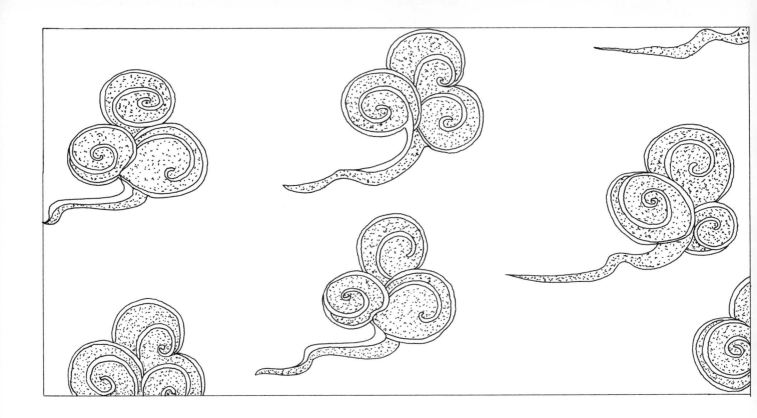

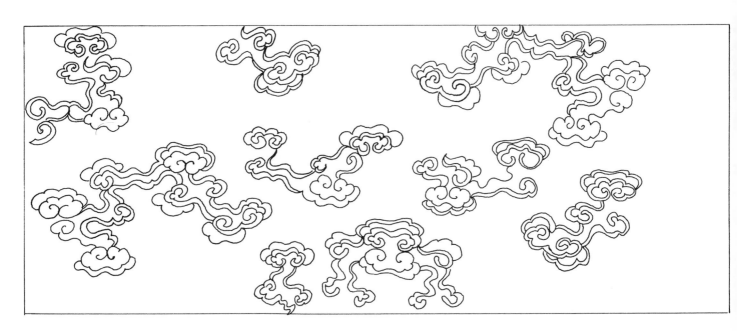

Cloud forms. TOP: From a ceramic. CENTER: From a Qing dynasty ceramic. BOTTOM: From a Ming dynasty porcelain.

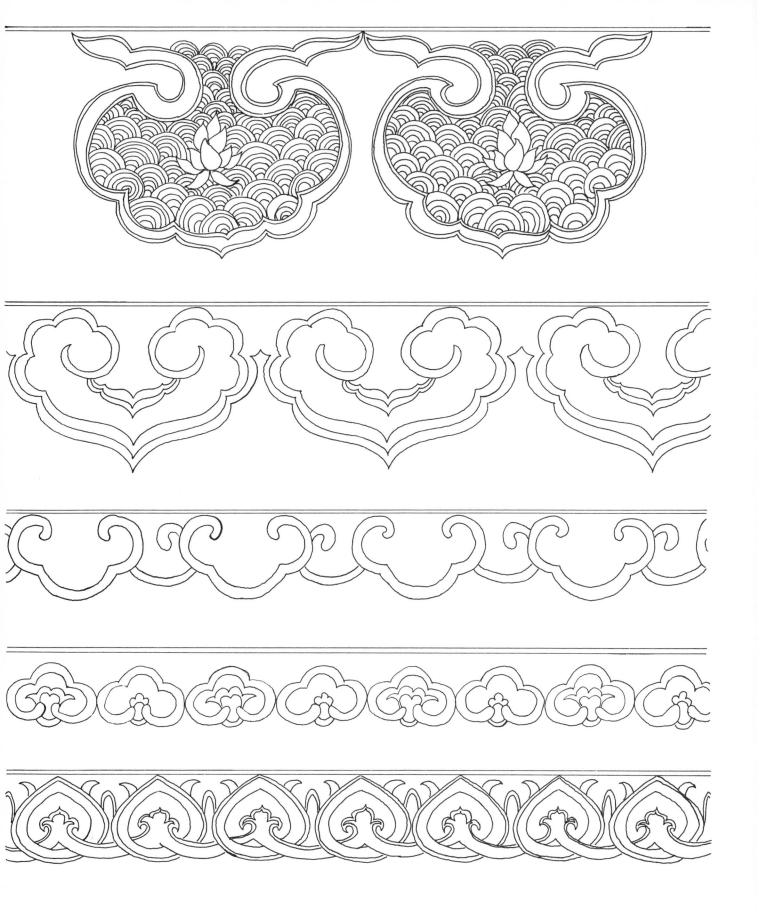

Cloud (and related) forms. FROM TOP TO BOTTOM: From a Yuan dynasty porcelain; from a late 15th-century (Ming dynasty) porcelain; from a porcelain of the Tong zhi period of the Qing dynasty; from an early Ming dynasty porcelain; from a porcelain of the Yong lo period of the Ming dynasty.

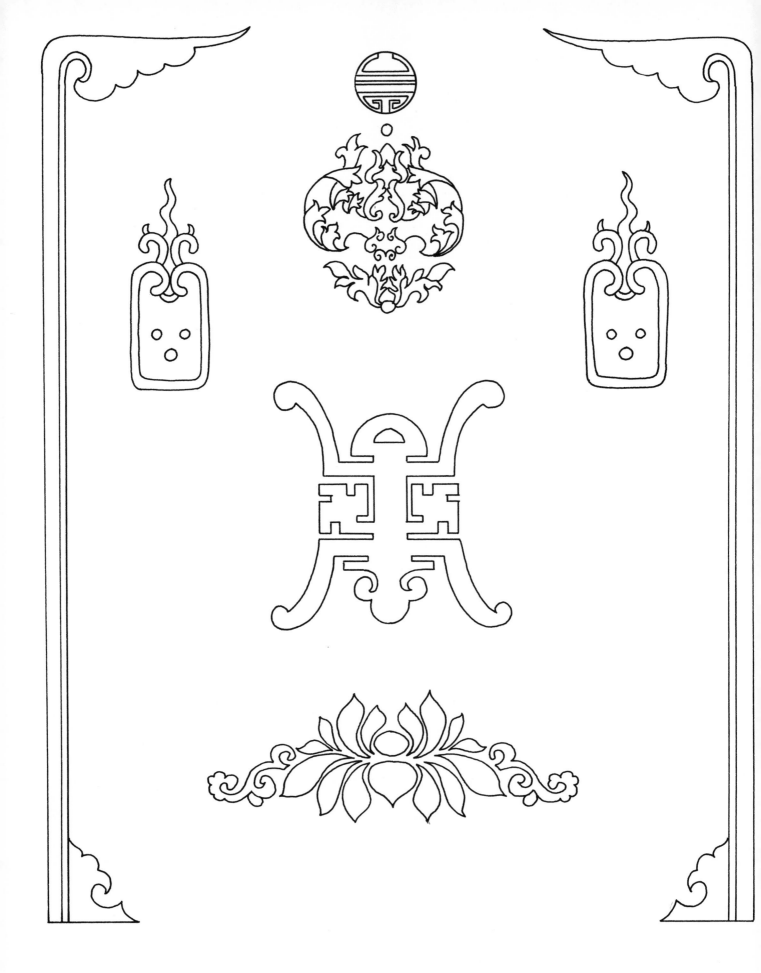

Borders from a Yuan dynasty porcelain. OTHER MOTIFS: From Qing dynasty lacquer.

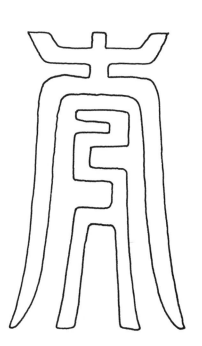

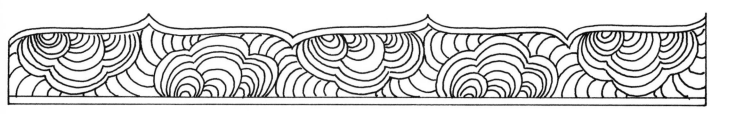

TOP: From Qing dynasty porcelain. CENTER: From a porcelain of the Jia jing period of the Ming dynasty.
BOTTOM: From a 16th-century (Ming dynasty) porcelain.

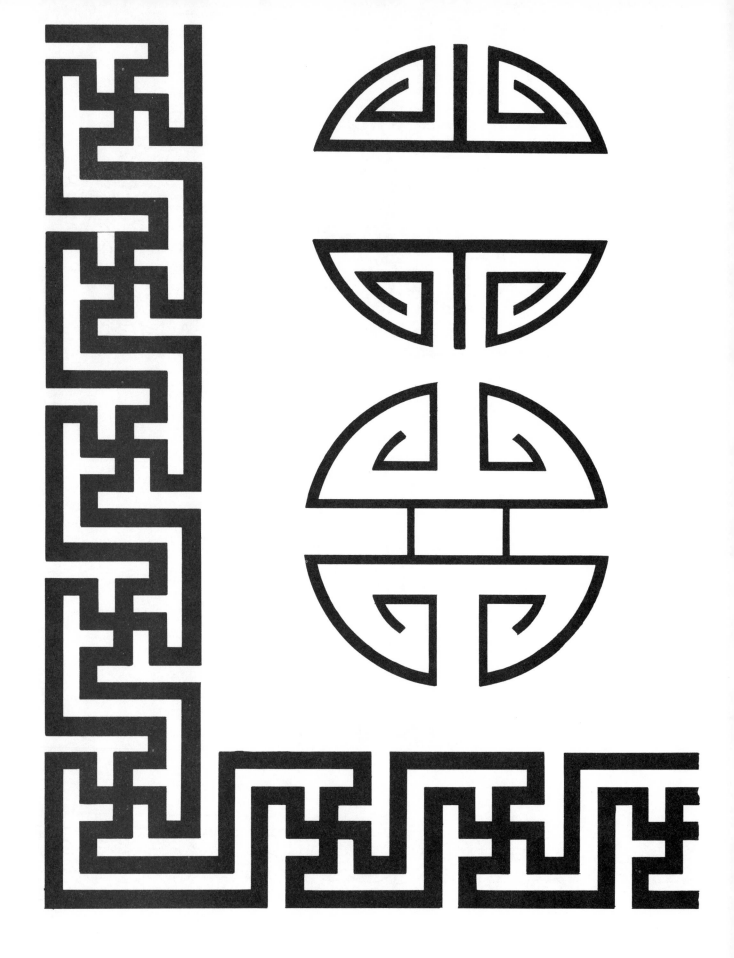

From an early Ming dynasty carpet.

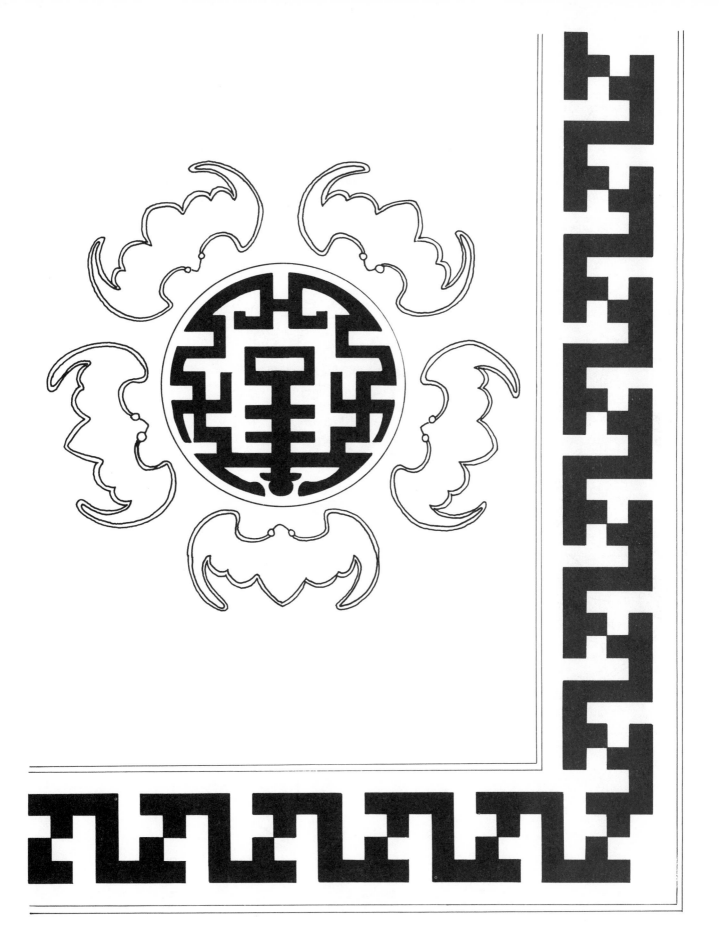

From a Ming dynasty carpet.

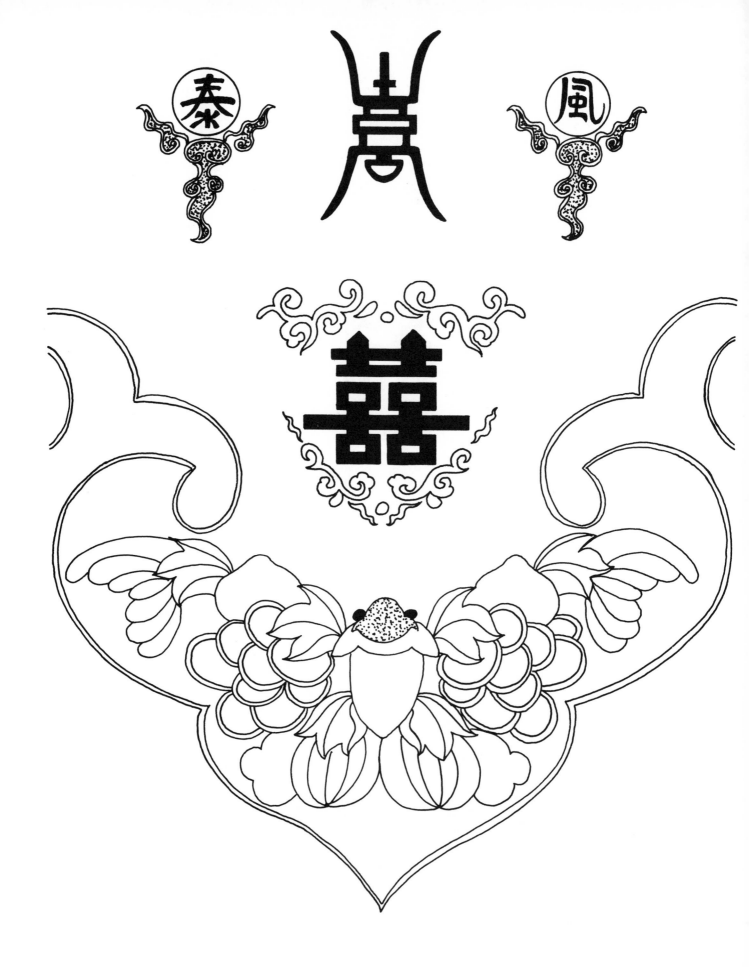

From 19th-century (Qing dynasty) textiles.

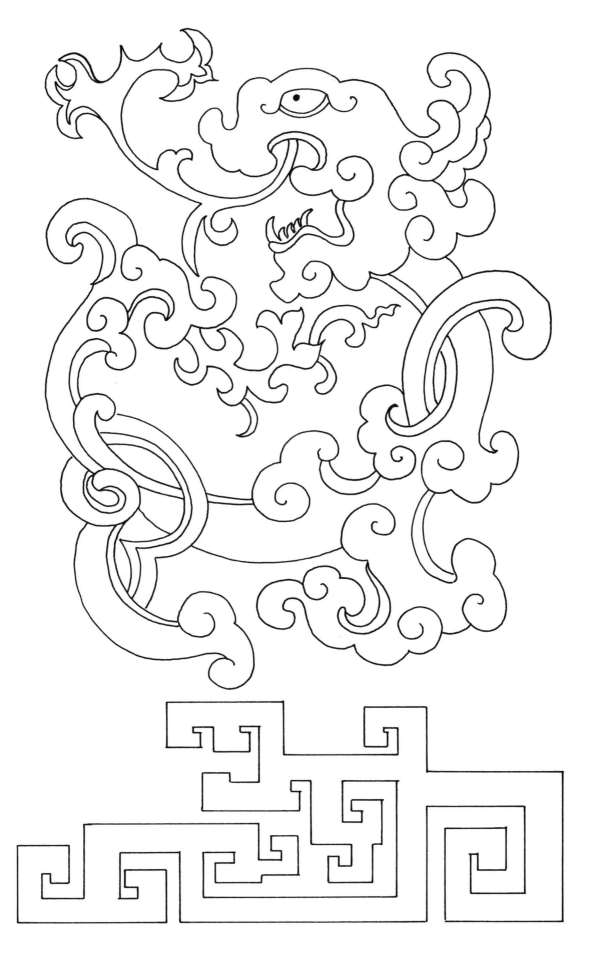

From 19th-century (Qing dynasty) textiles.

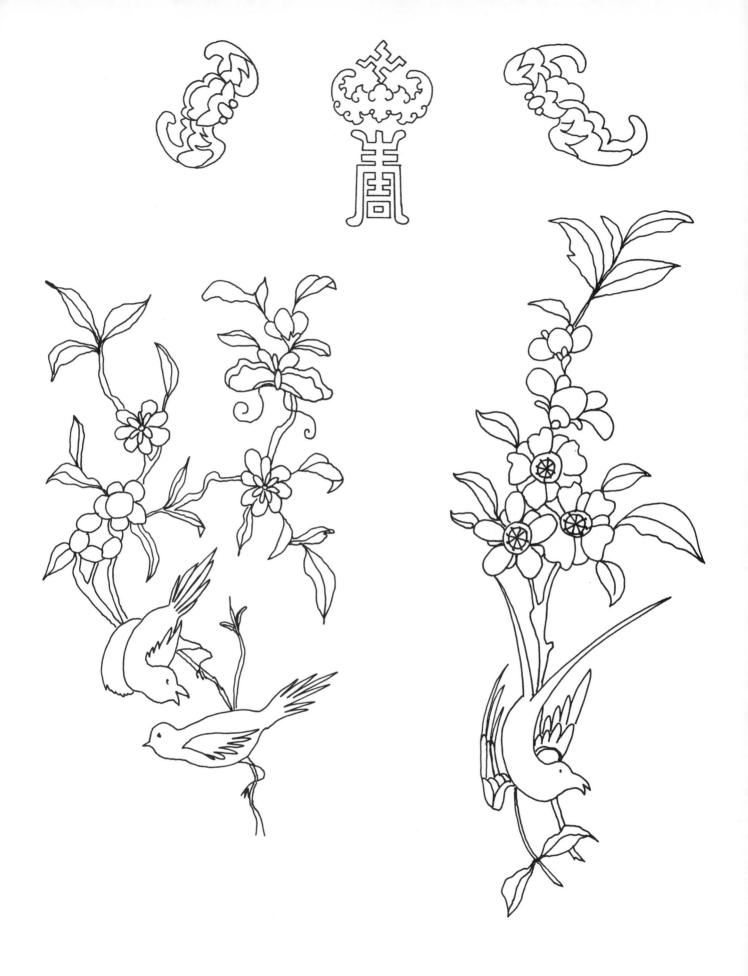

TOP ROW: From Ming dynasty porcelain. BOTTOM ROW: From 19th-century (Qing dynasty) textiles.

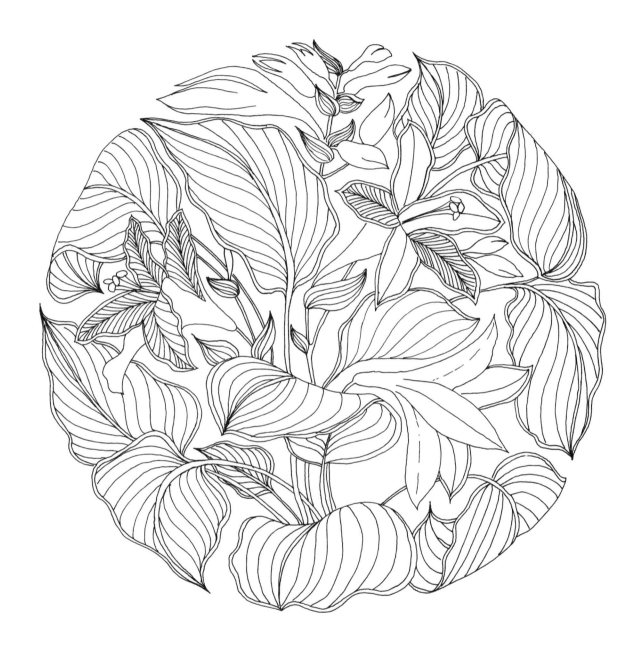

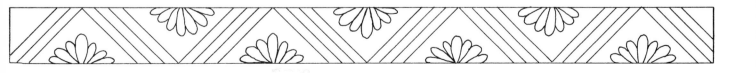

TOP: From Song dynasty pottery. CENTER: From Song dynasty lacquer. BOTTOM: From Qing dynasty porcelain.

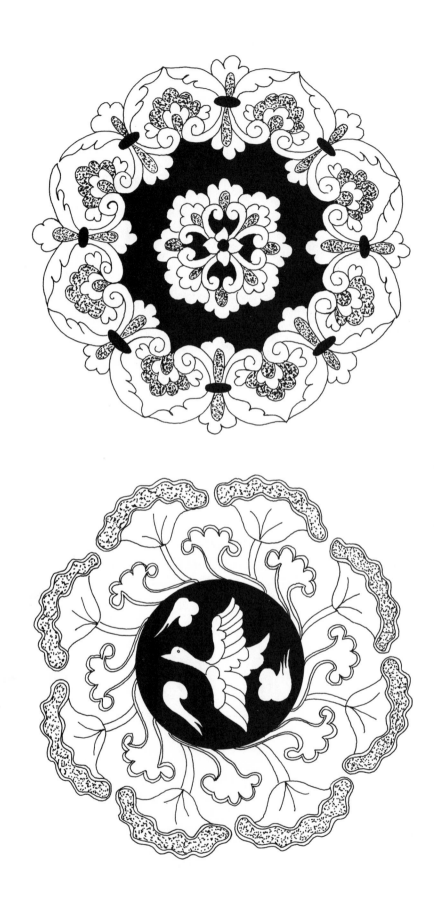

From Tang ceramics.

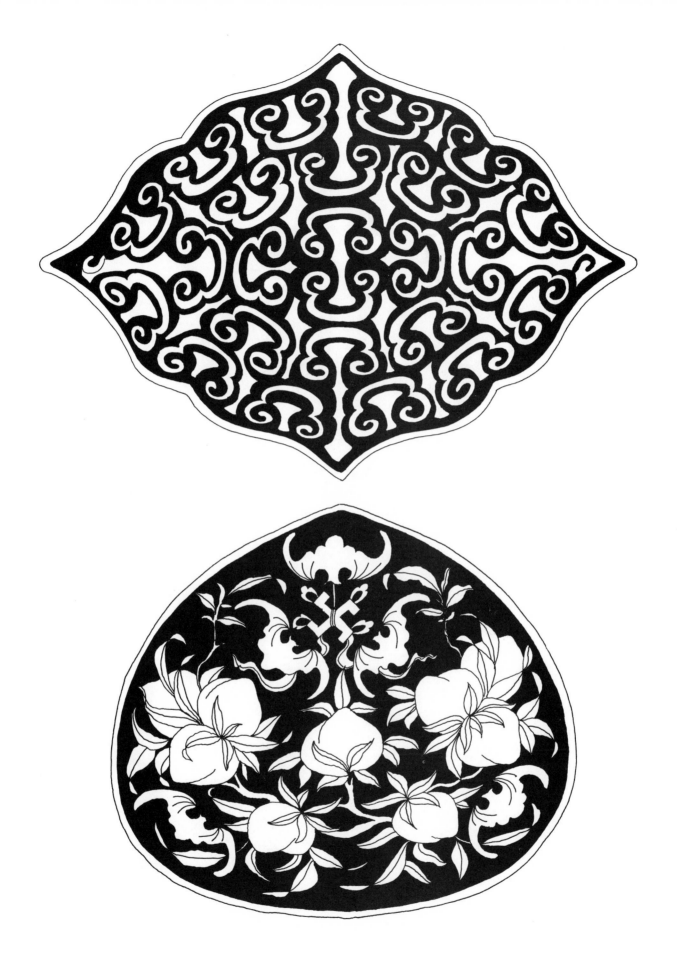

From Ming dynasty lacquer (top: cloud motif).

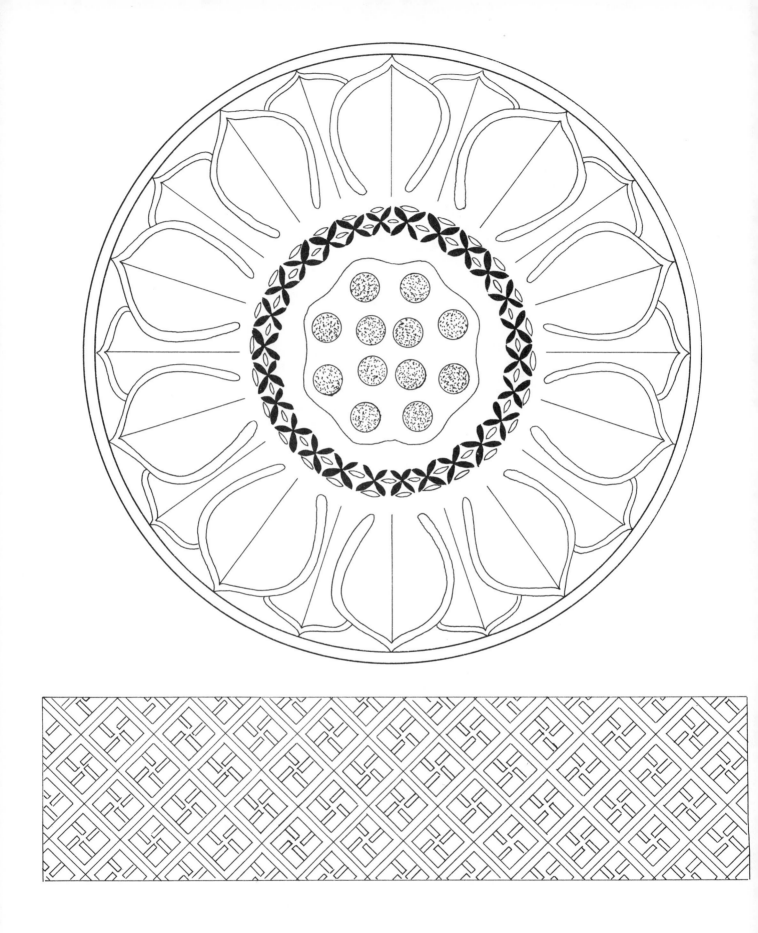

From Yuan dynasty lacquer (top: lotus motif).

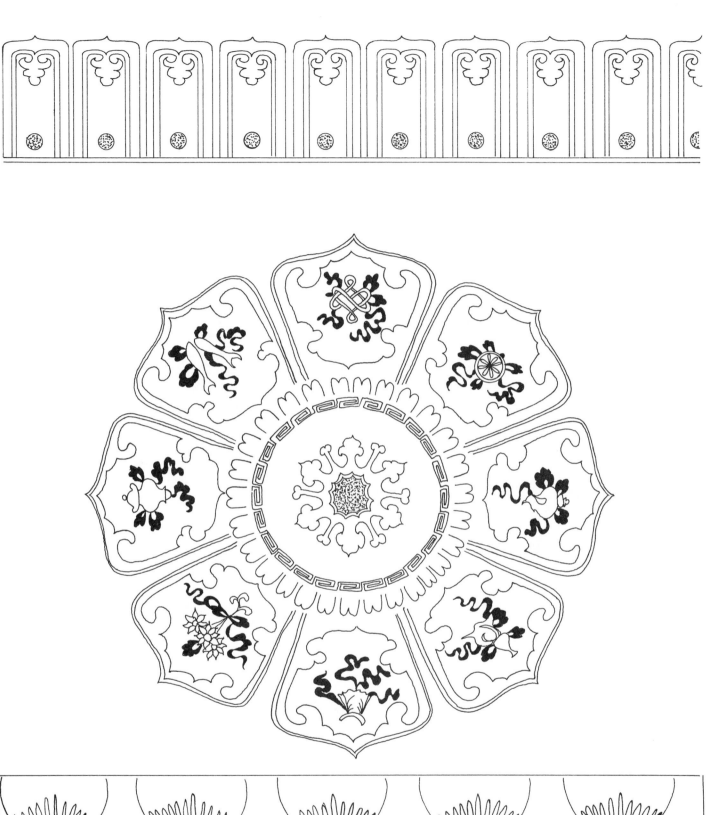

TOP & CENTER: From Ming dynasty porcelain (center: the "eight Buddhist symbols"). BOTTOM: From a porcelain
of the Hong zhi period of the Ming dynasty.

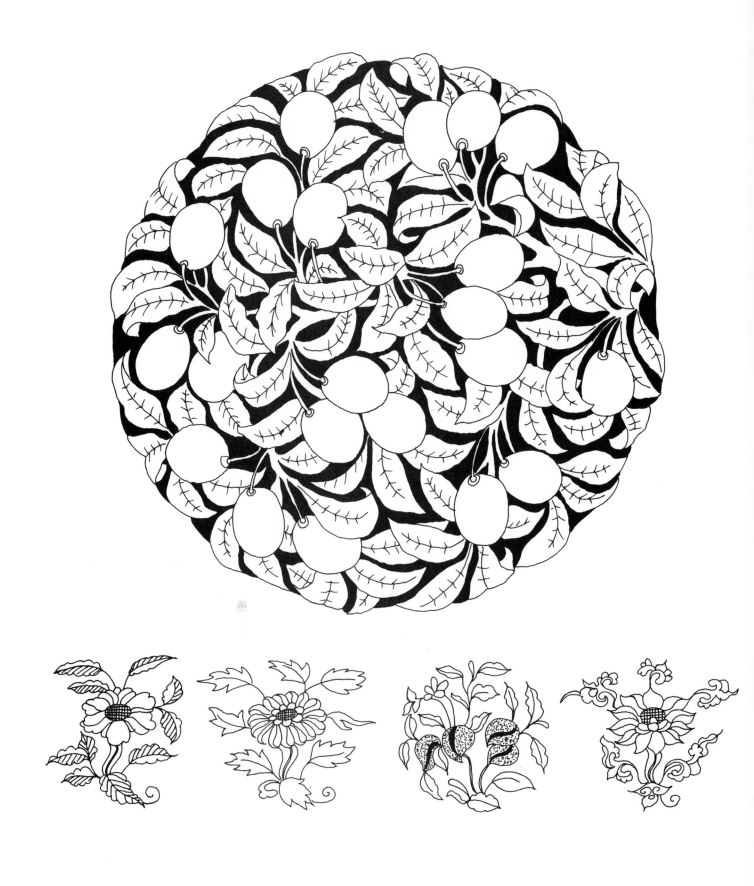

TOP: From lacquer. BOTTOM ROW: From Qing dynasty porcelain.

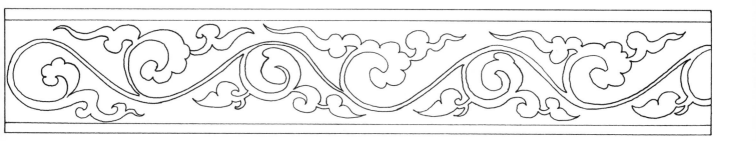

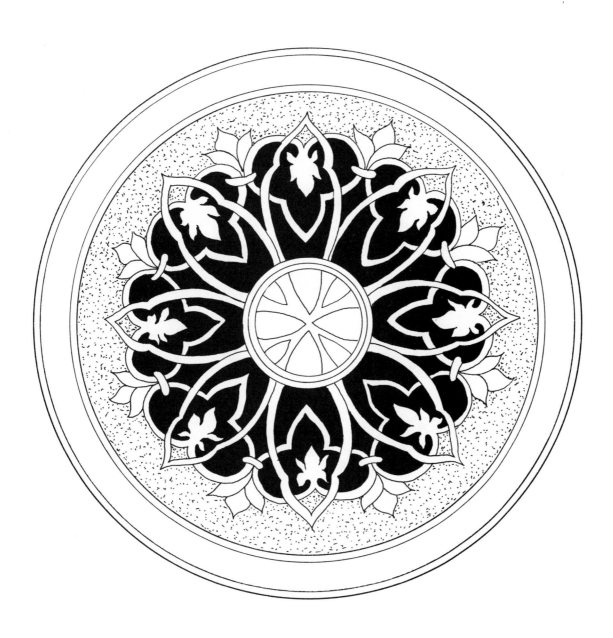

From porcelain of the Xuan de period of the Ming dynasty.

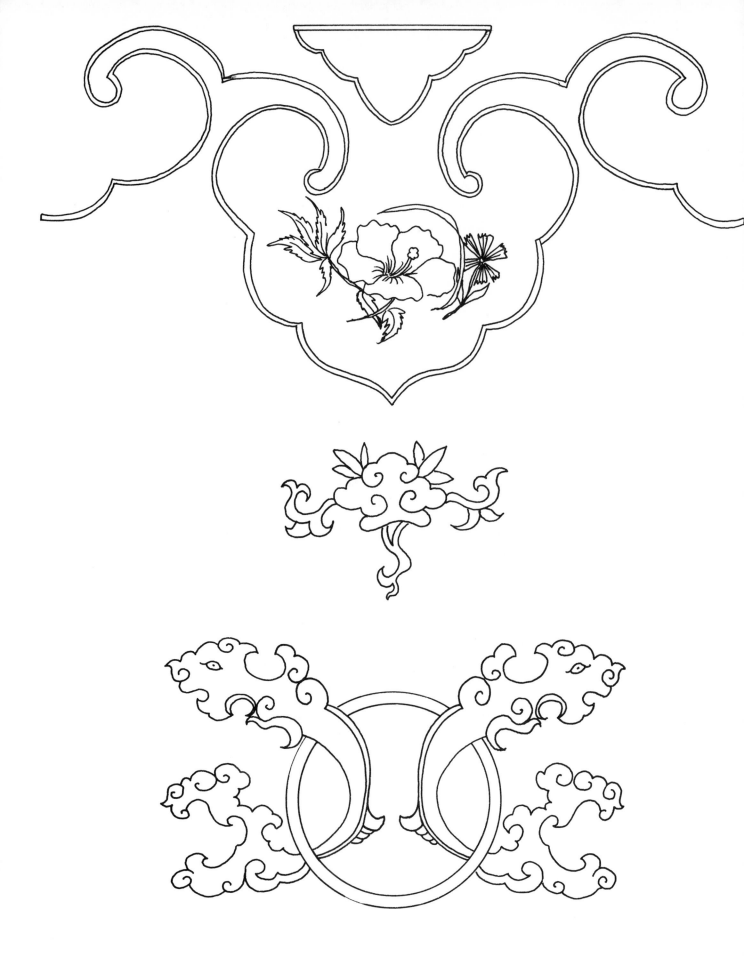

From 19th-century (Qing dynasty) textiles.

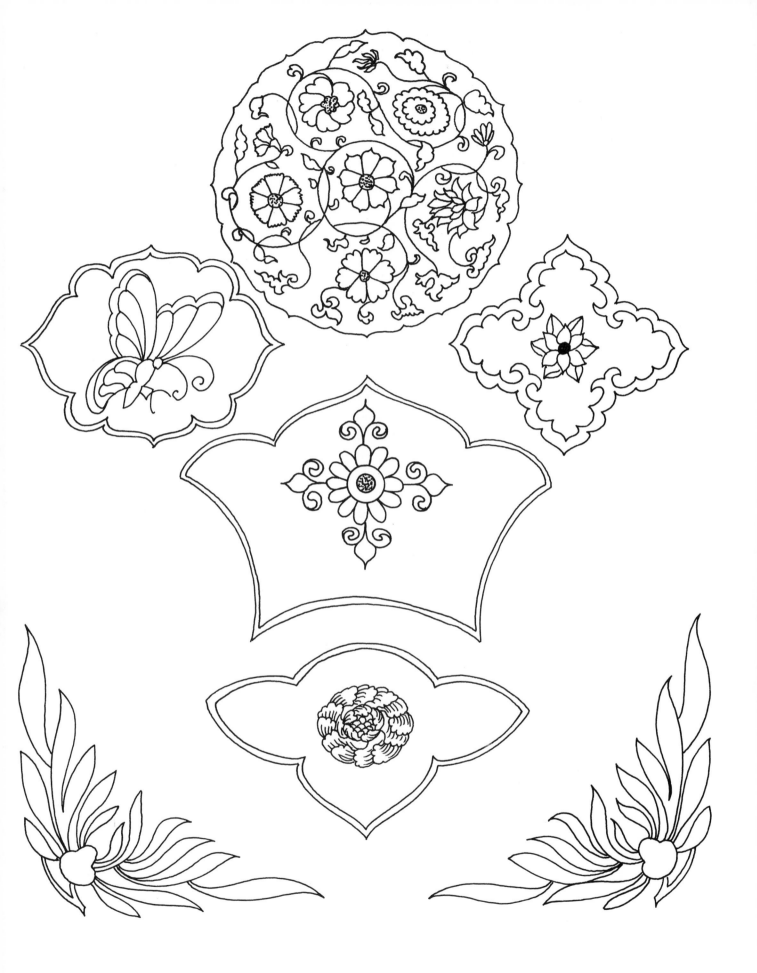

From Ming dynasty porcelain.

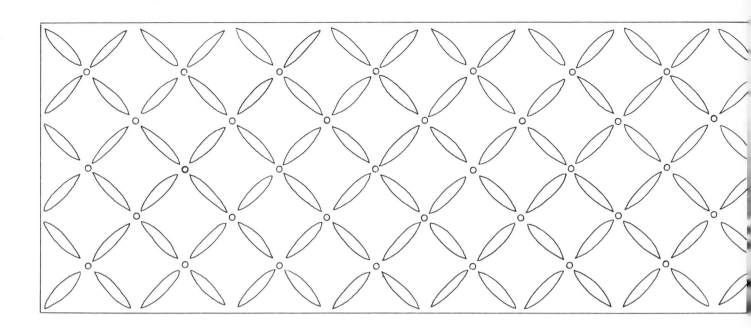

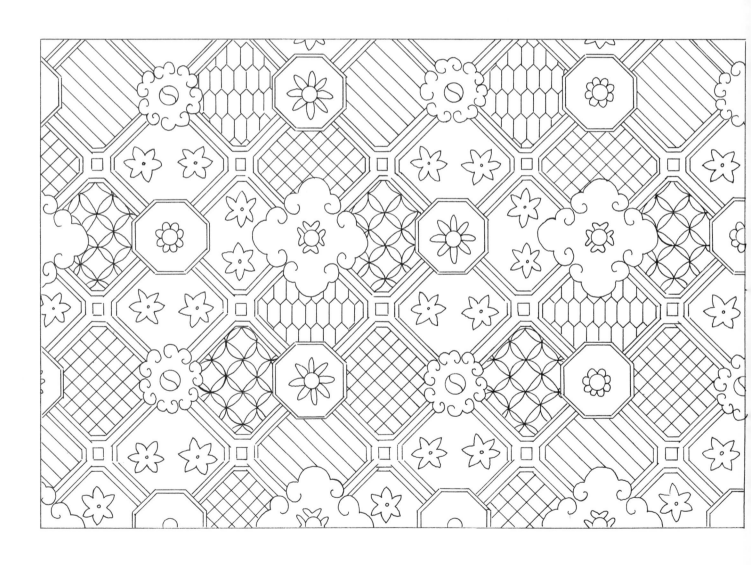

TOP: From porcelain. BOTTOM: From 19th-century (Qing dynasty) embroidery.

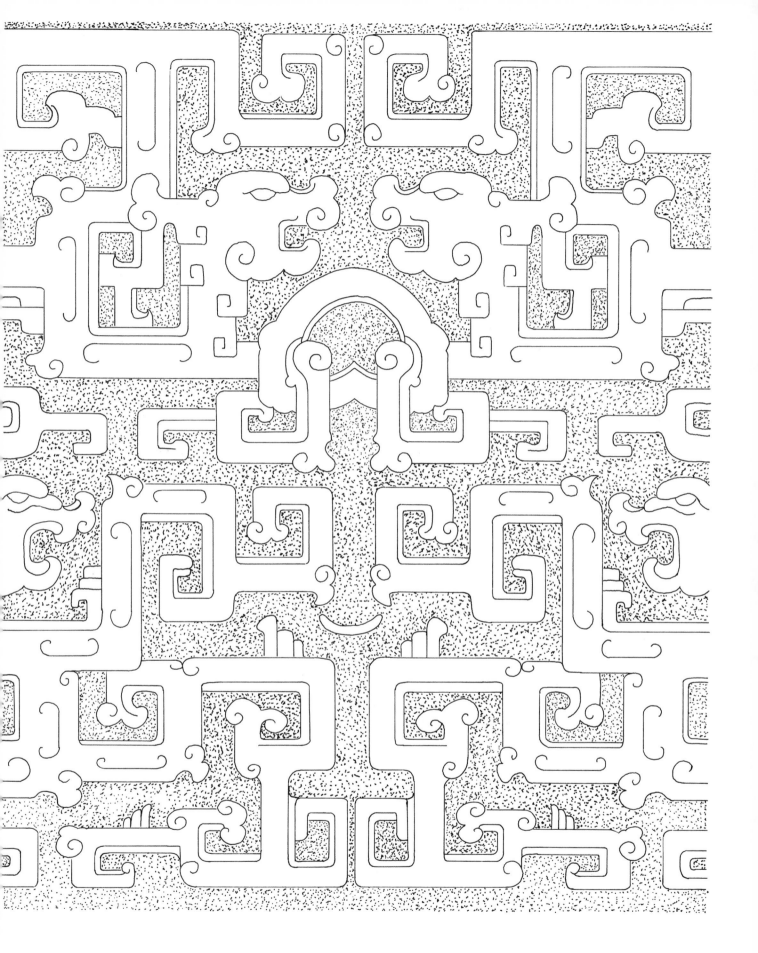

Winged dragons from an 18th-century (Qing dynasty) celadon glazed plaque.

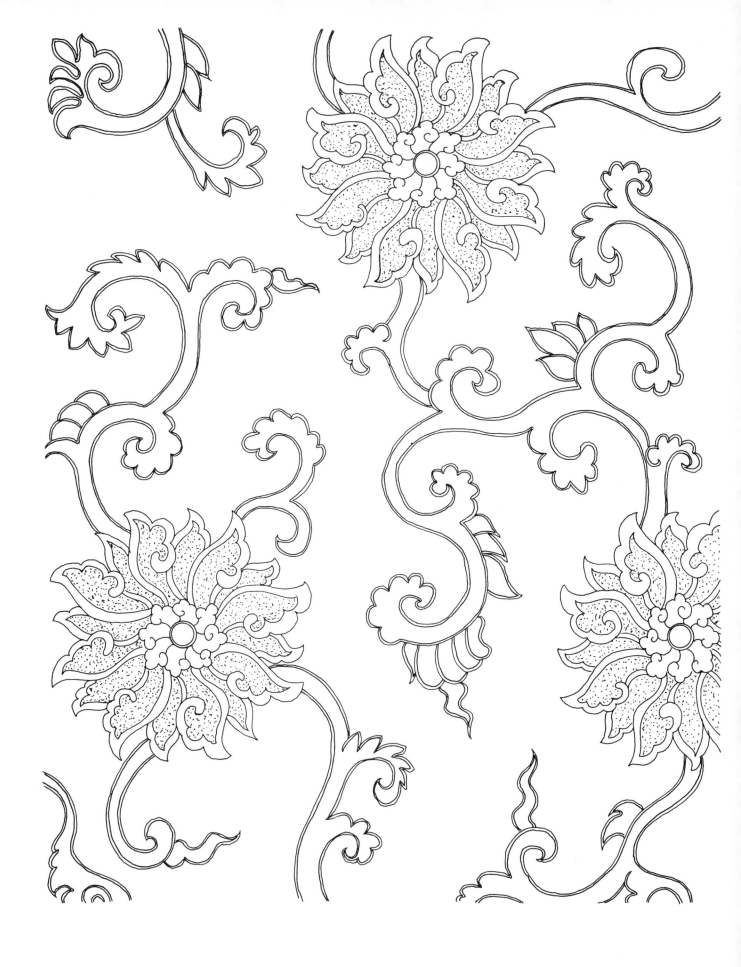

Lotus flowers on a scrolling leaf vine from a carpet of the Kang xi period of the Qing dynasty.

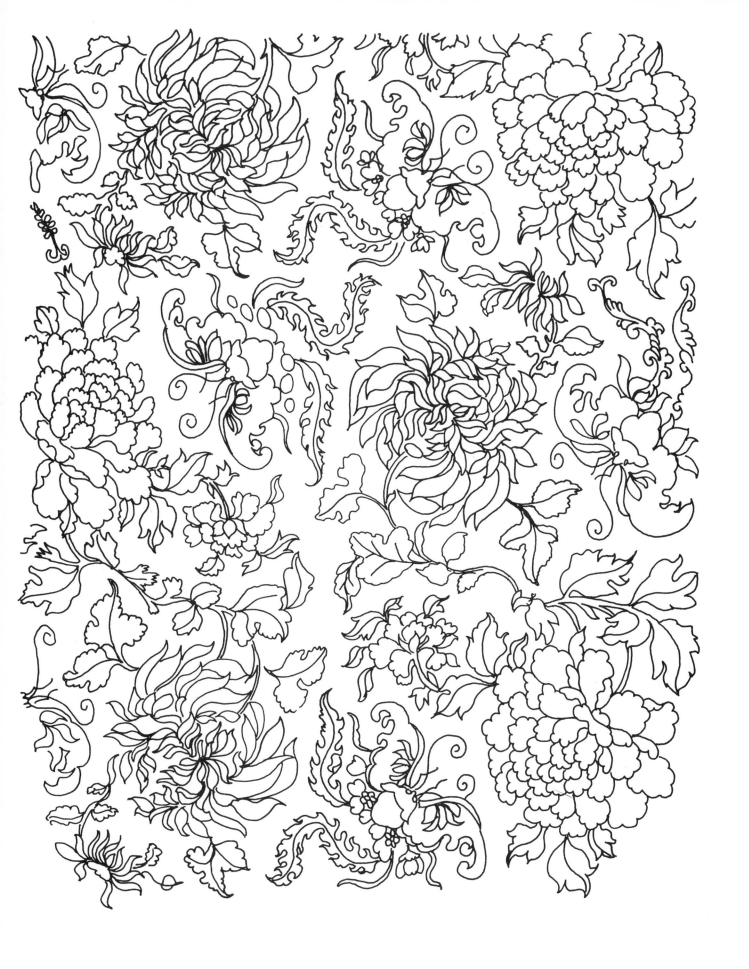

From a 19th-century (Qing dynasty) textile.

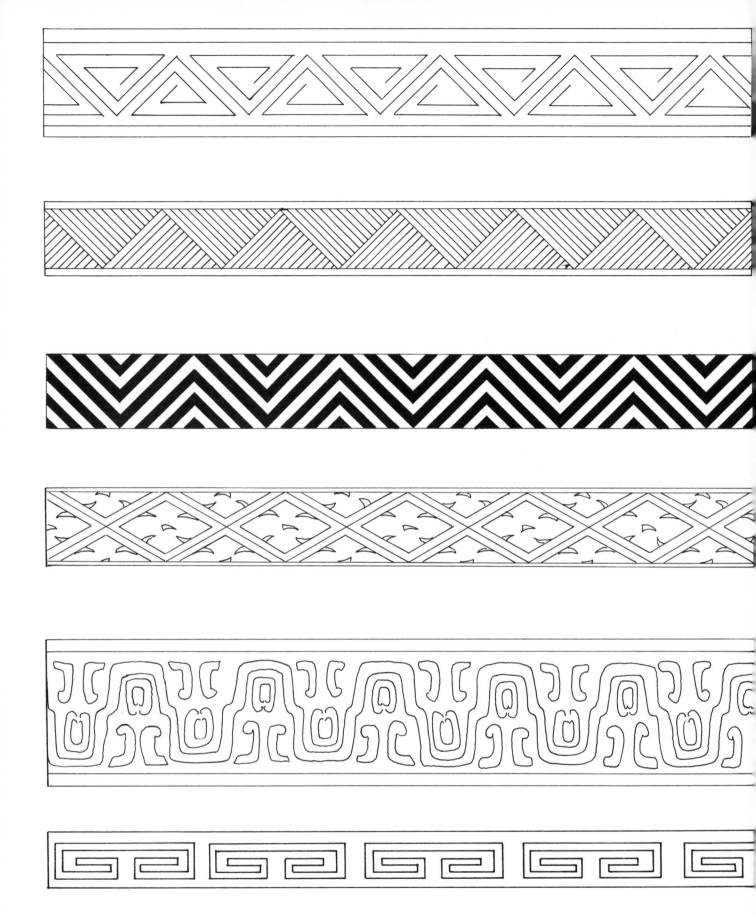

TOP: Yong lo period, Ming dynasty. FOURTH DOWN: From an early Ming dynasty porcelain. FIFTH: From a Zhou dynasty bronze, ca. 770 B.C. SIXTH: From a porcelain of the Yong zheng period of the Qing dynasty.

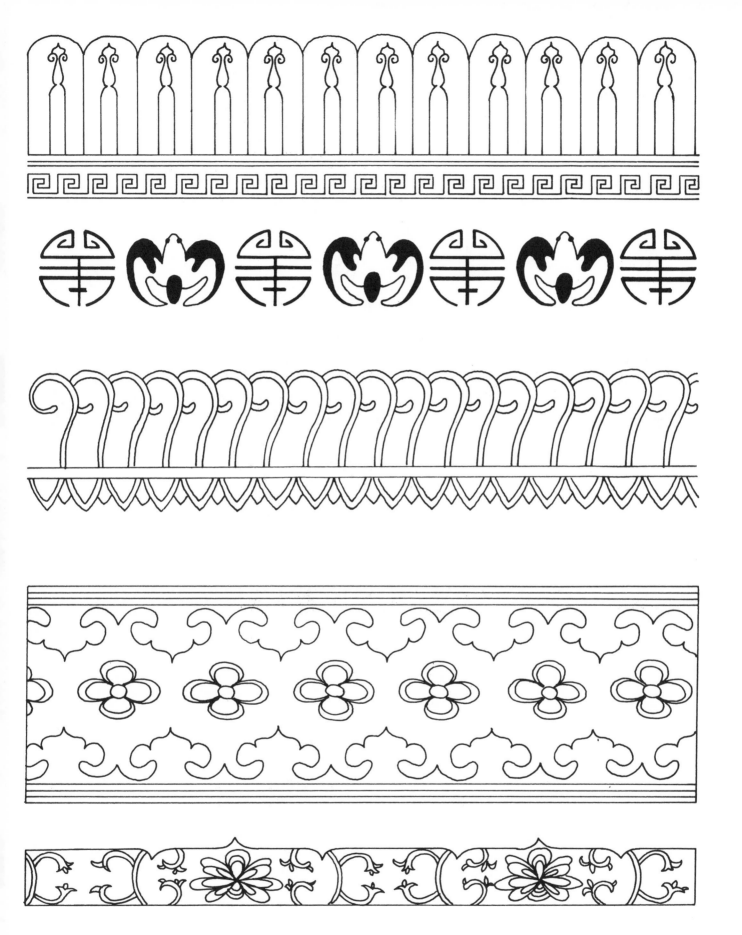

TOP, CENTER & BOTTOM: From a Ming porcelain. SECOND AND FOURTH BANDS: From 19th-century (Qing dynasty) textiles.

 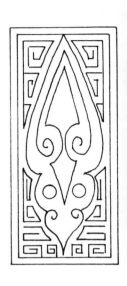

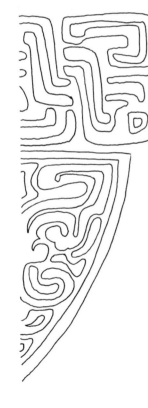 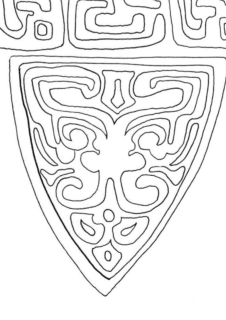

From Zhou dynasty bronzes.

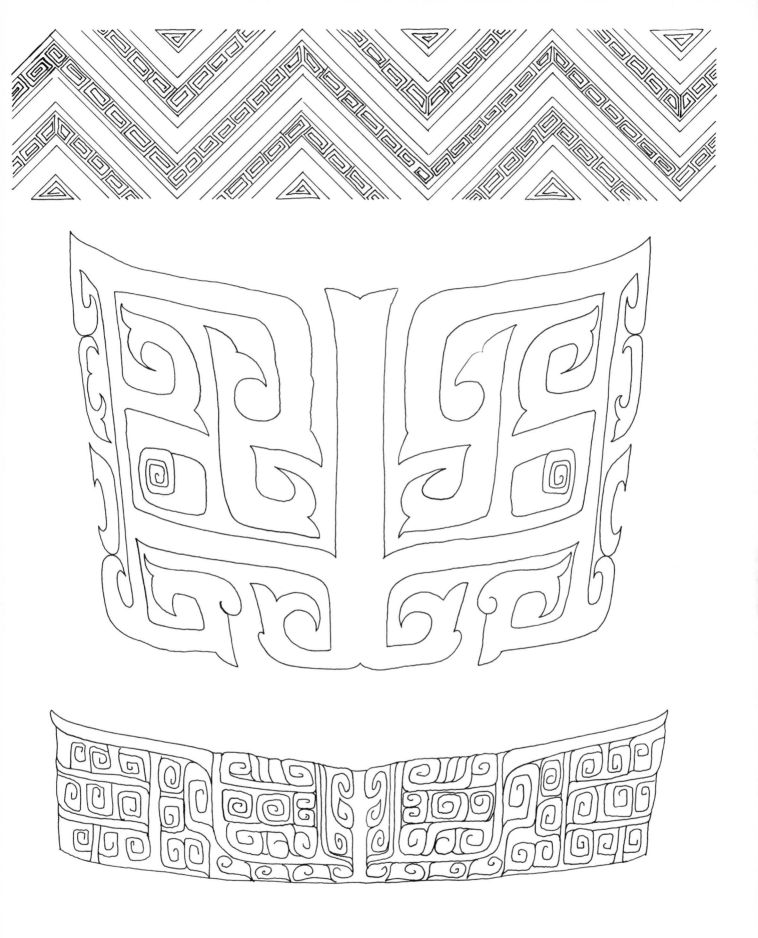

TOP: Thunder design from unglazed pottery, ca. 1300 B.C. CENTER & BOTTOM: Animal-mask
motifs from bronzes, ca. 1300 B.C.

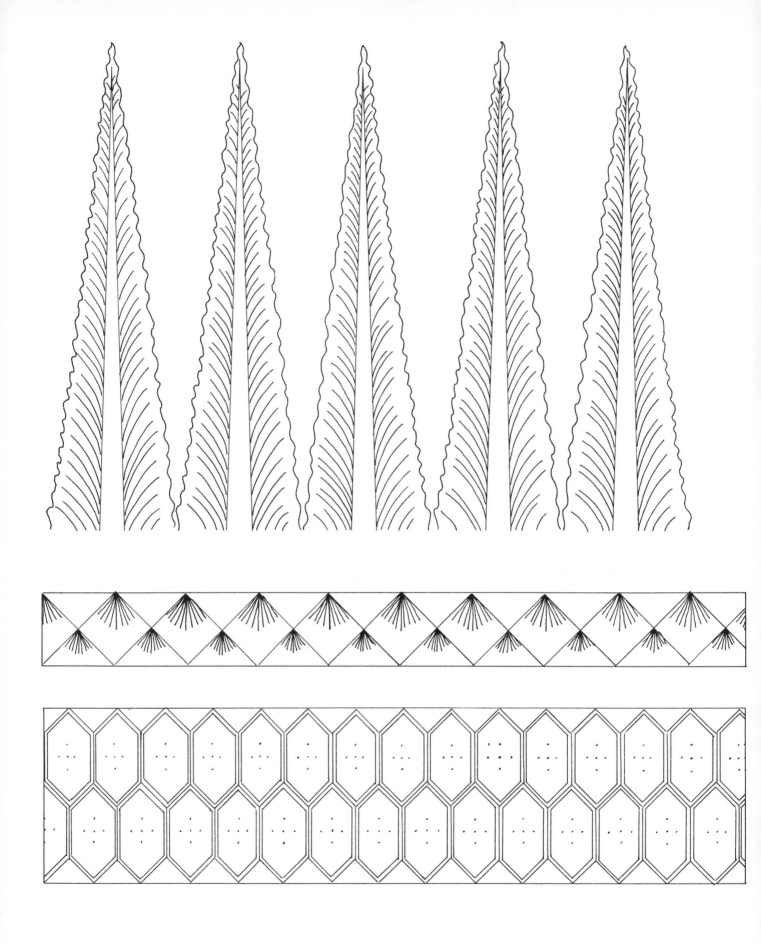

TOP: Plantain leaf from a porcelain of the Hong zhi period of the Ming dynasty. CENTER & BOTTOM: From porcelain of the Jia jing period of the Ming dynasty.

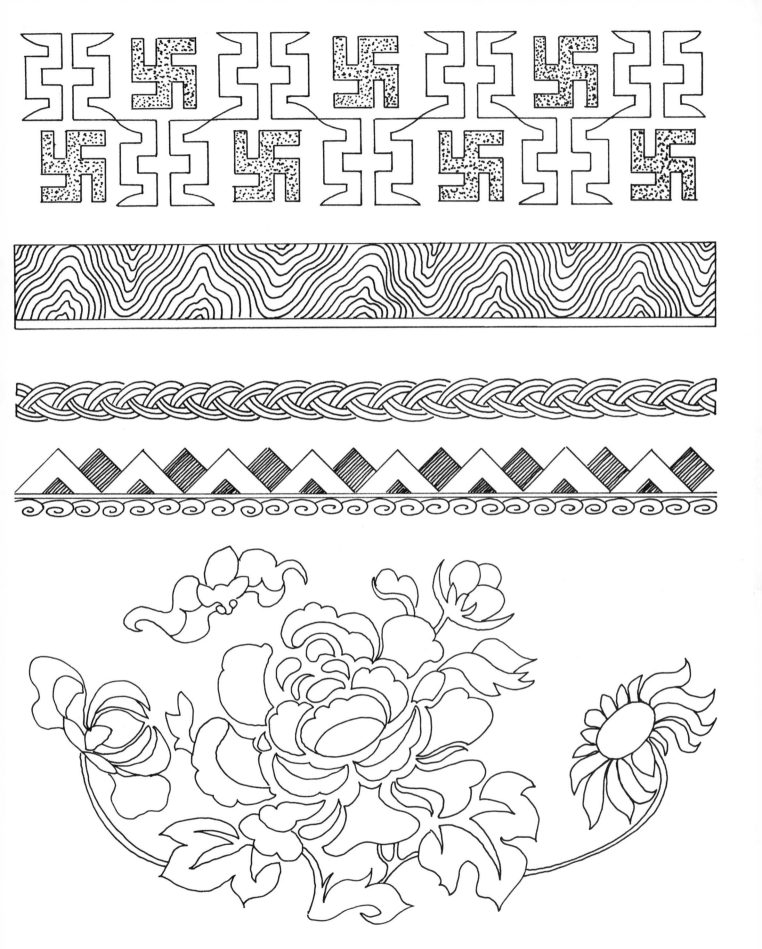

TOP & BOTTOM: From 19th-century (Qing dynasty) textiles. THE NARROW BANDS: From a porcelain of the Xuan de period of the Ming dynasty; cord pattern from a Zhou dynasty bronze; from a 16th-century (Ming dynasty) porcelain.

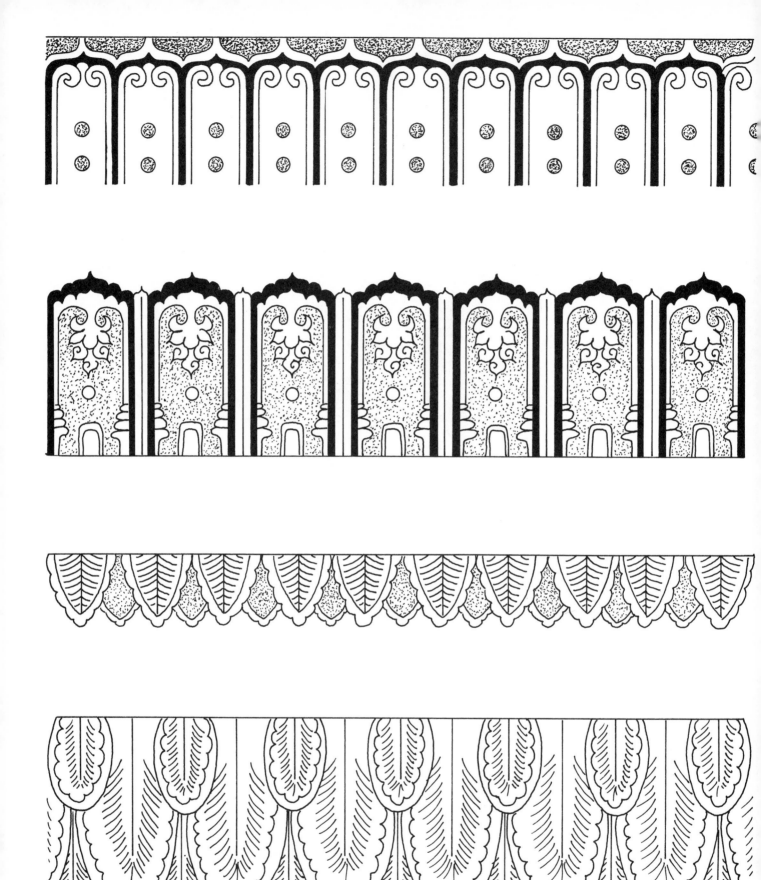

TOP TO BOTTOM: Lotus panels from a porcelain of the Qian long period of the Qing dynasty;
lotus panels from a Ming dynasty porcelain; peony leaves from an early Ming dynasty porcelain;
plantain leaves from a Tang dynasty porcelain.

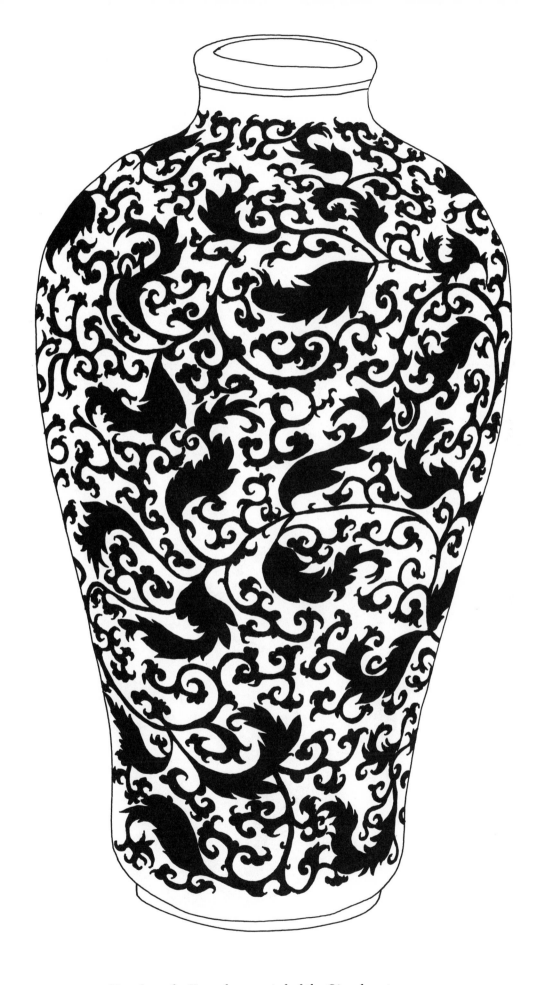

Vase from the Yong zheng period of the Qing dynasty.

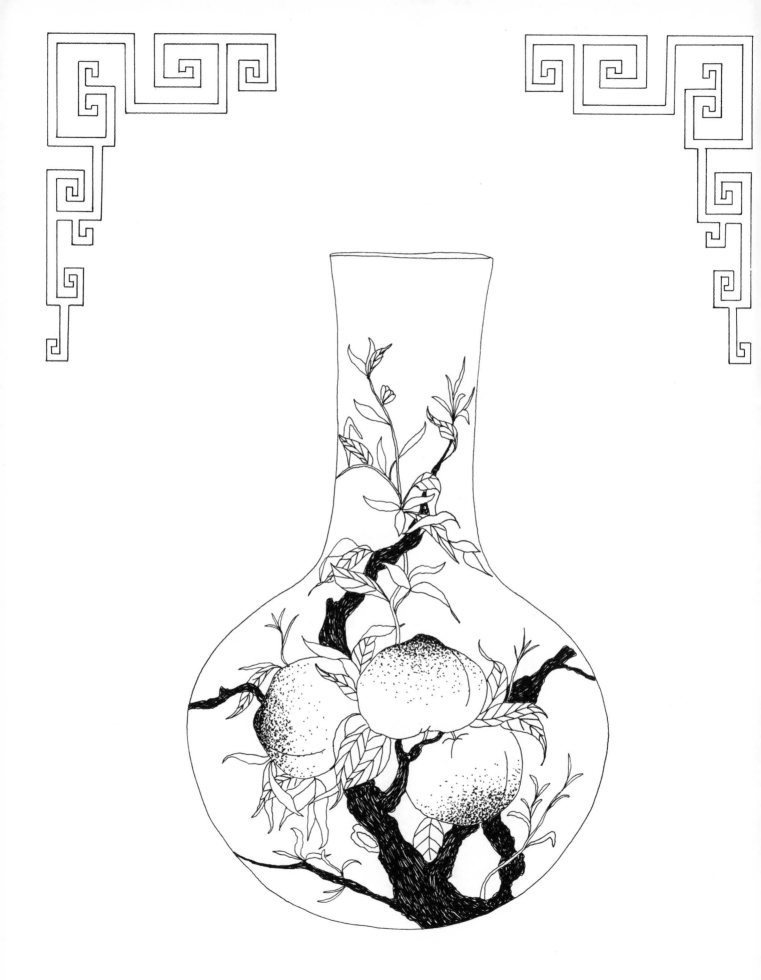

TOP: Corner motifs from a textile. BOTTOM: Porcelain vase of the Yong zheng period of the Qing dynasty.

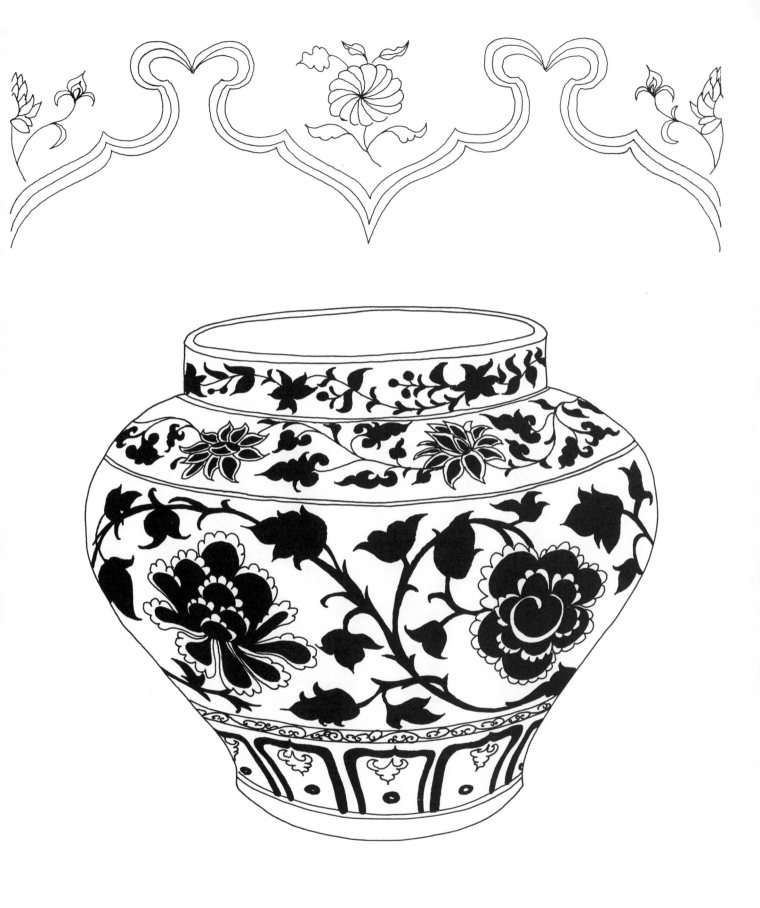

Xuan de period of the Ming dynasty.

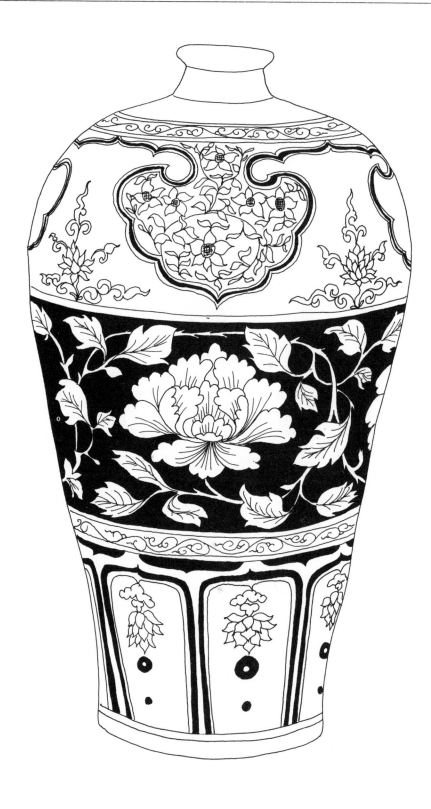

Early Ming dynasty (second half of the 14th century).

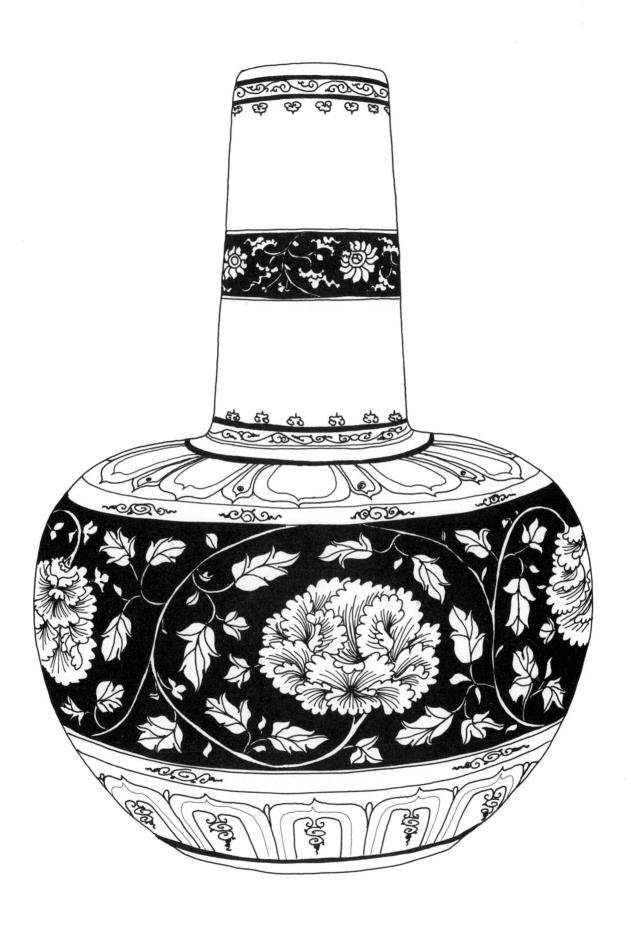

Bottle vase, 15th century (Ming dynasty).

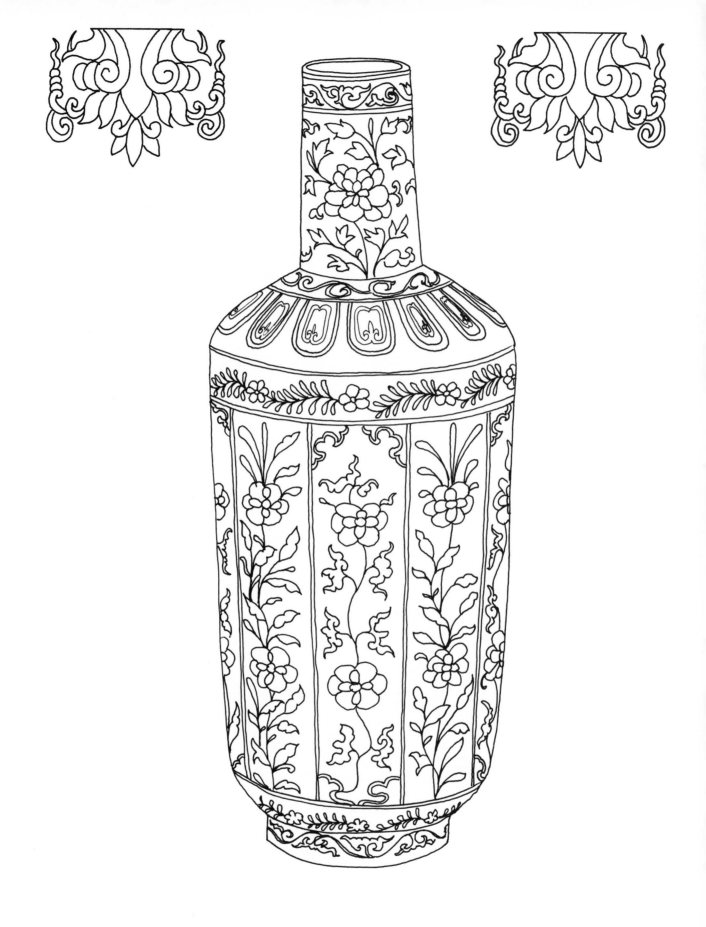

18th century (Qing dynasty).

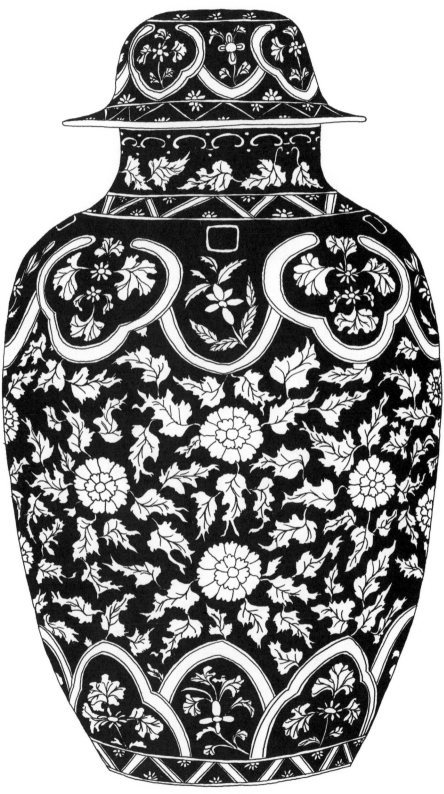

Ming dynasty.

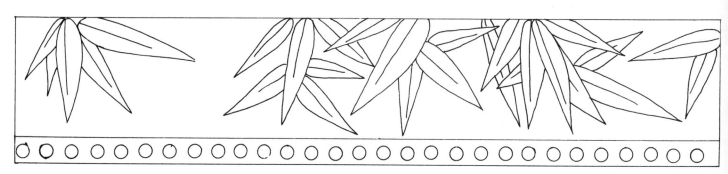

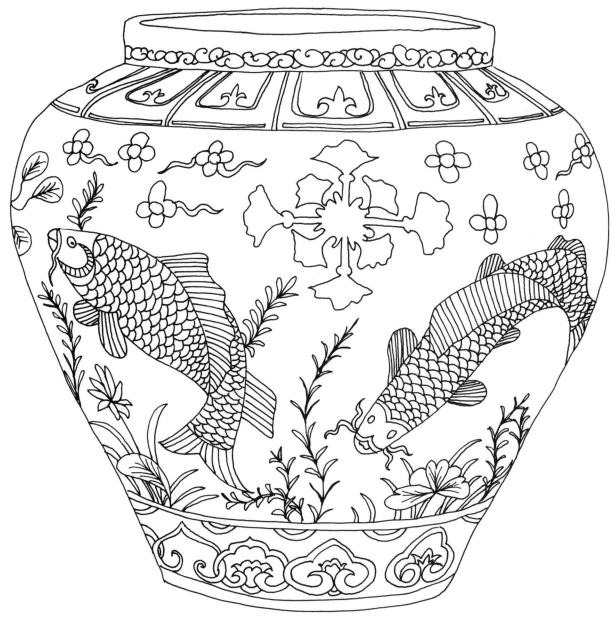

Jar, 16th century (Ming dynasty).

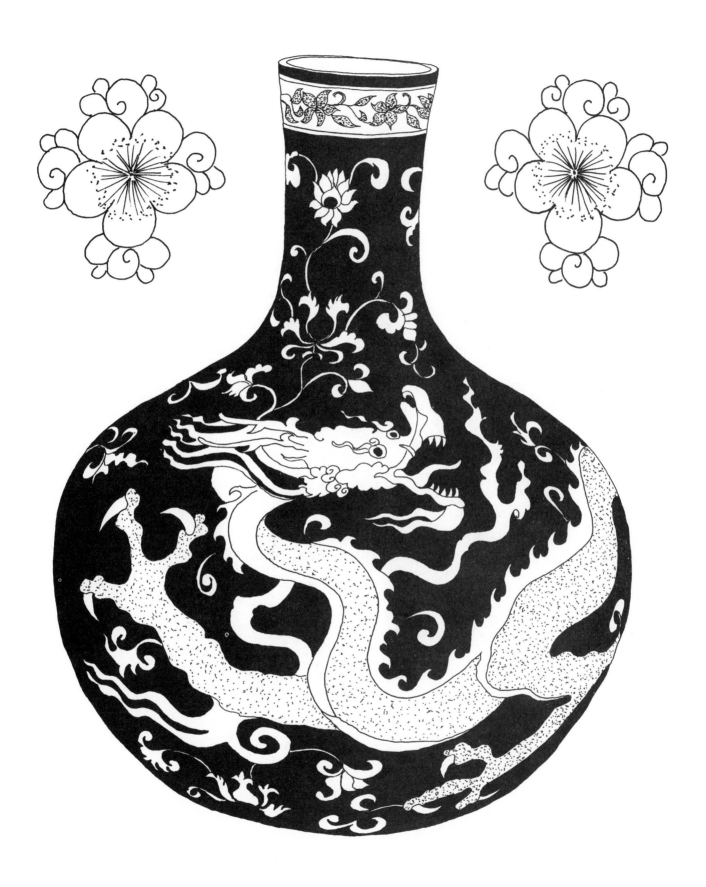

Ming dynasty.

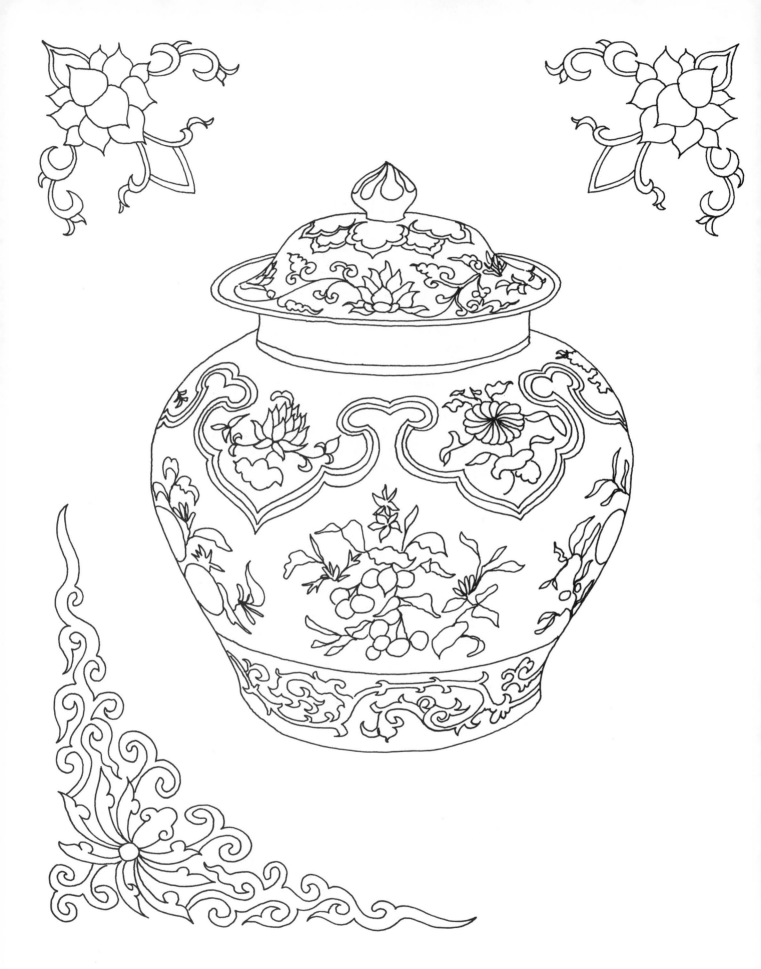

Early Ming covered jar. Upper corner motifs from a porcelain of the Kang xi period of the Qing dynasty;
lower corner motif from 19th-century (Qing dynasty) textile.

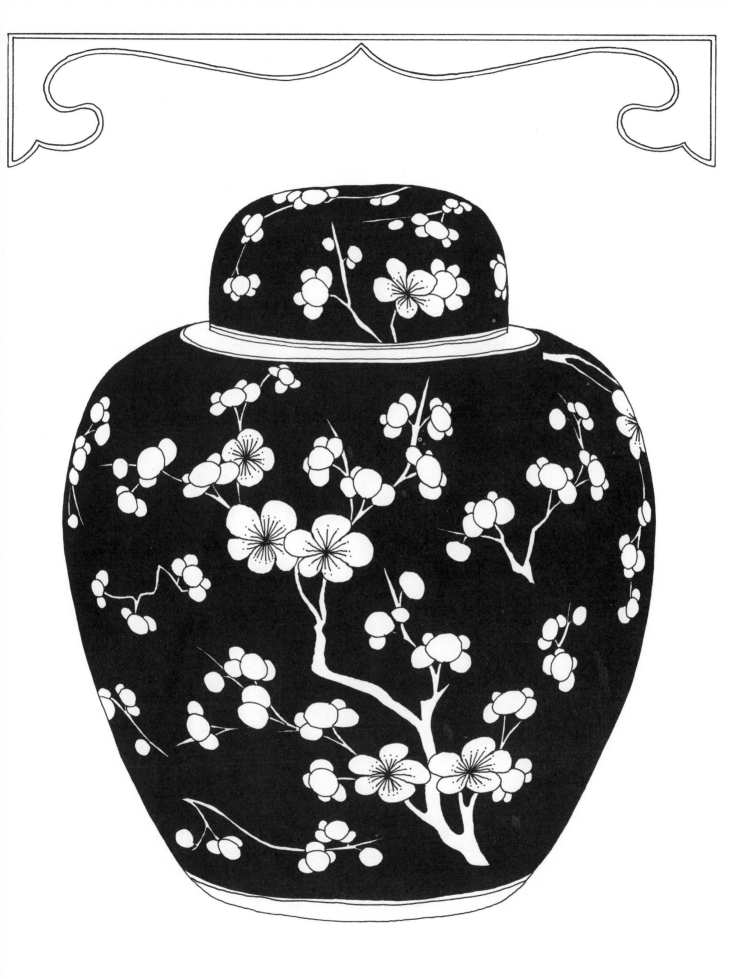

Ming dynasty.

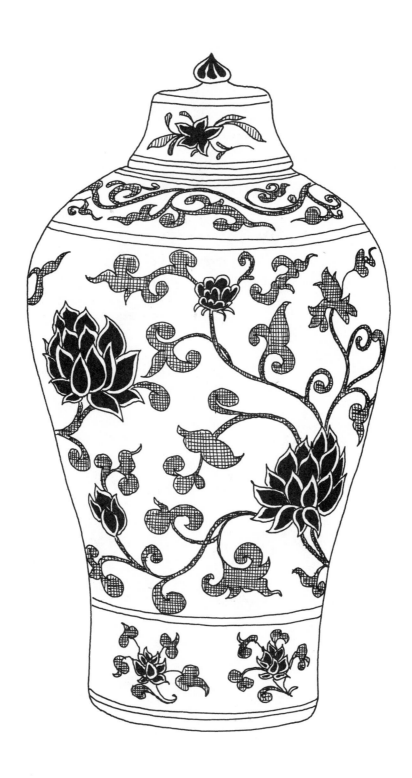

Ming covered jar. Top border from a Qing dynasty ceramic.

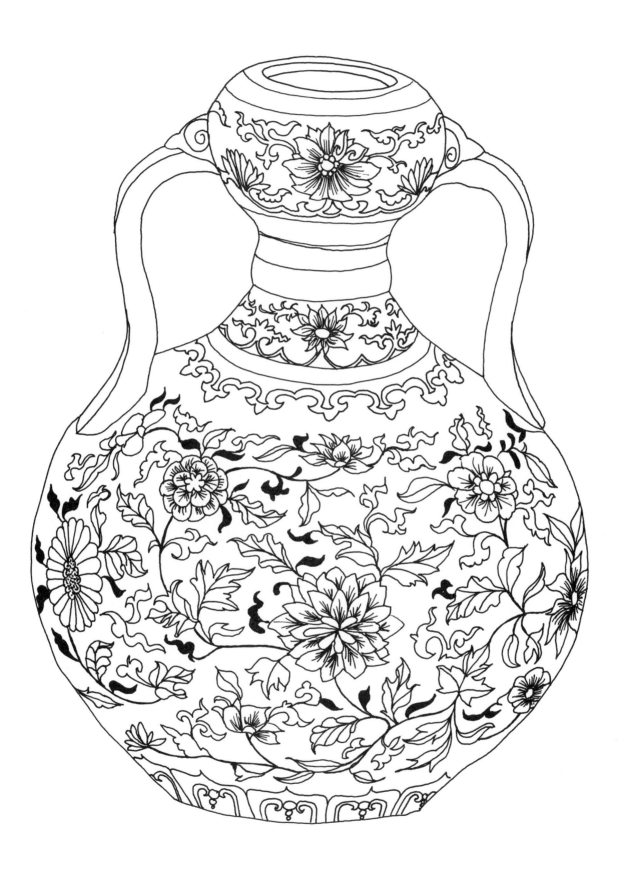

Flask, Yong zheng period of the Qing dynasty.

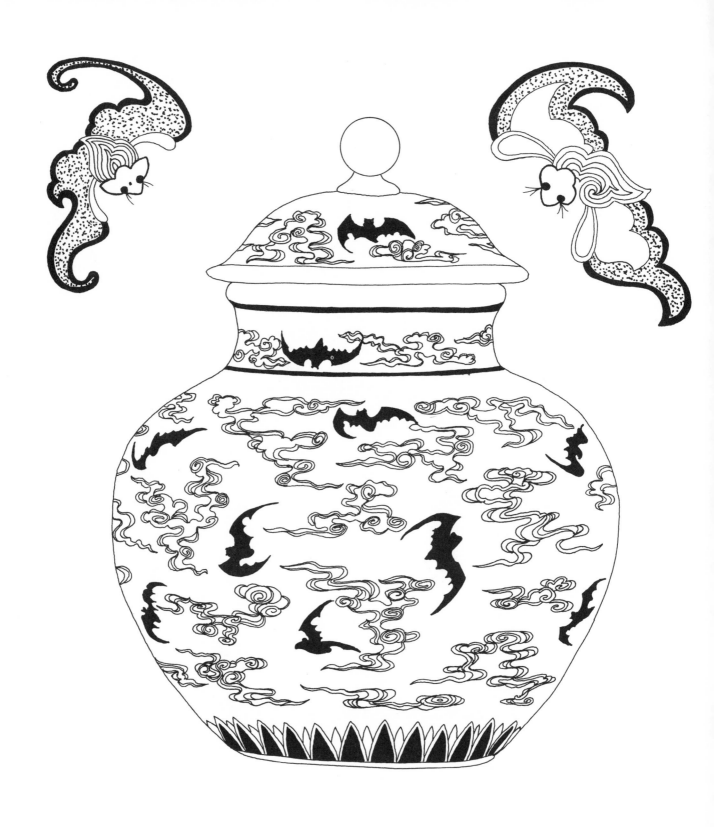

Covered jar, Qian long period of the Qing dynasty. Corner bat motifs from a 19th-century (Qing dynasty) textile.

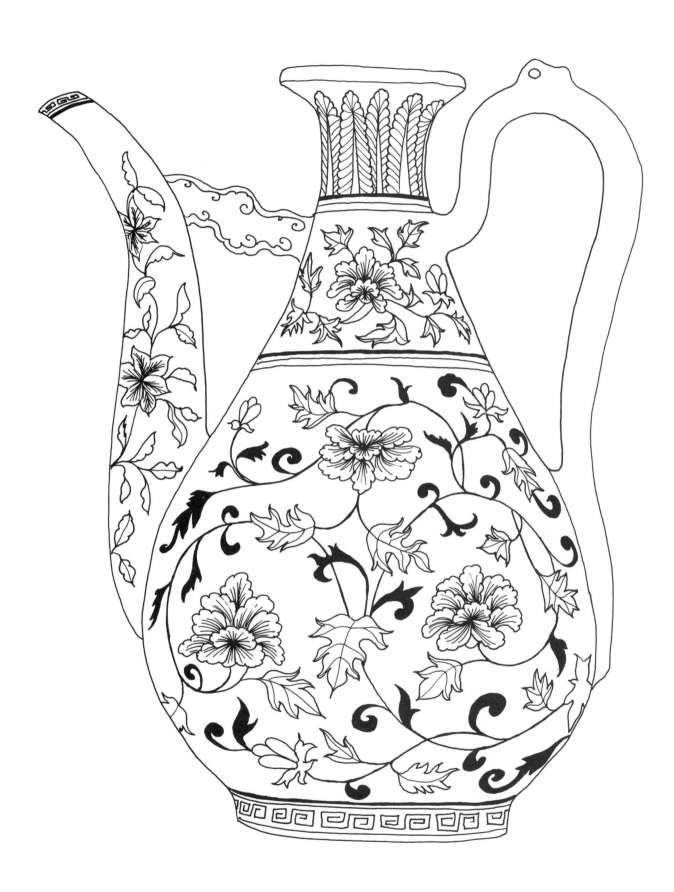

Pitcher, 15th century (Ming dynasty).

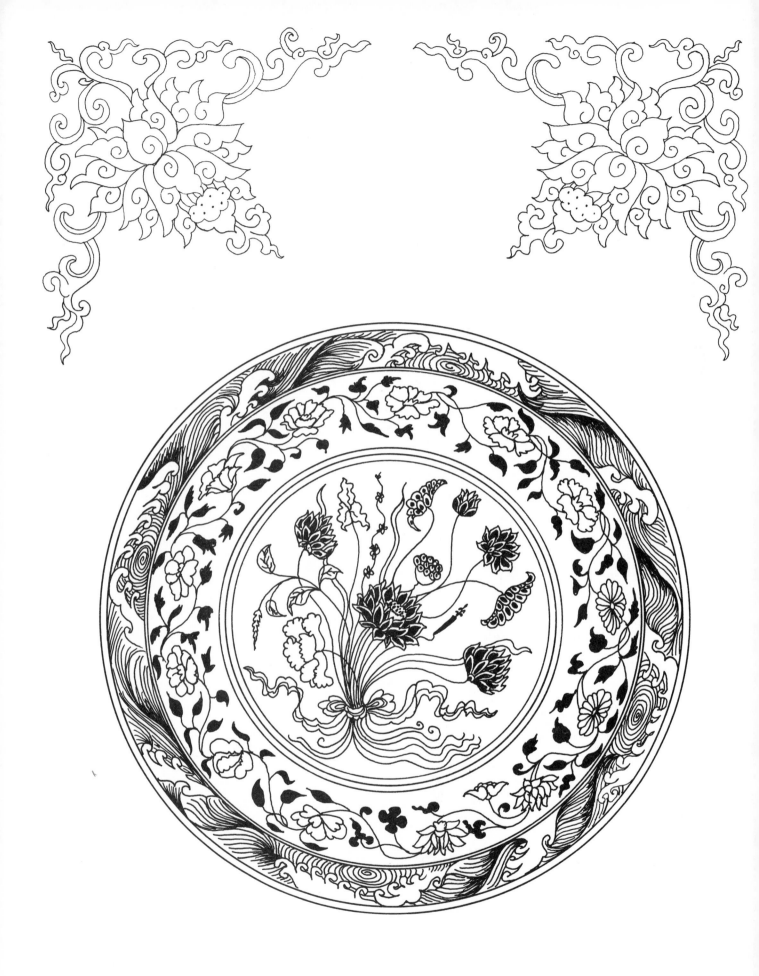

Dish, early Ming dynasty.

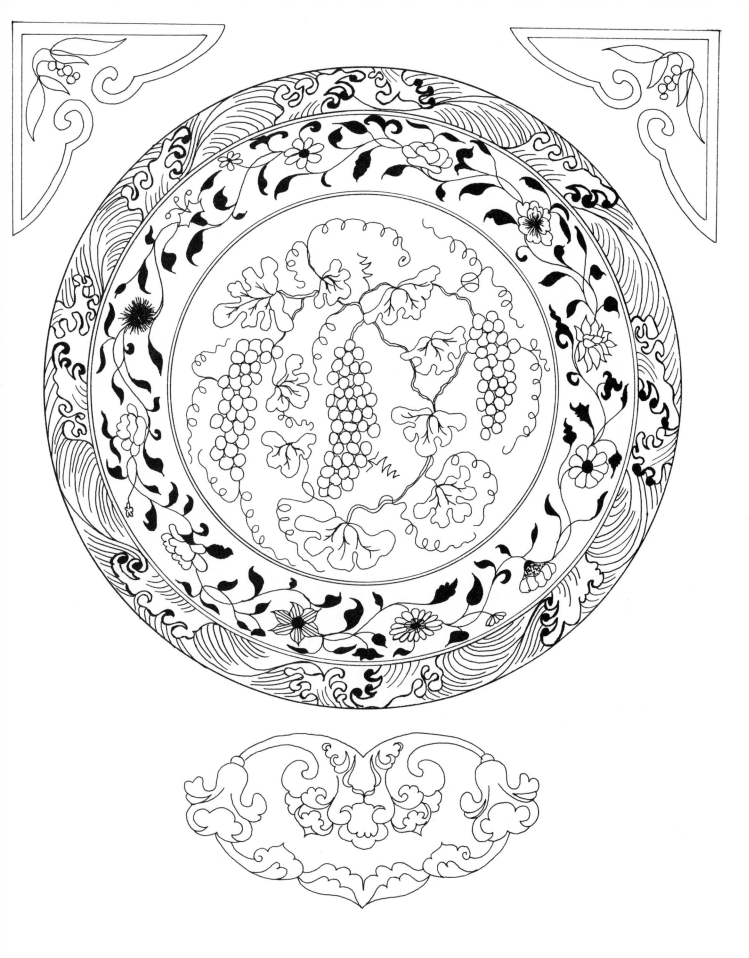

Early Ming dish. Top corner motifs from a 19th-century (Qing dynasty) rank badge.
BOTTOM: From a Tang dynasty metal tray.

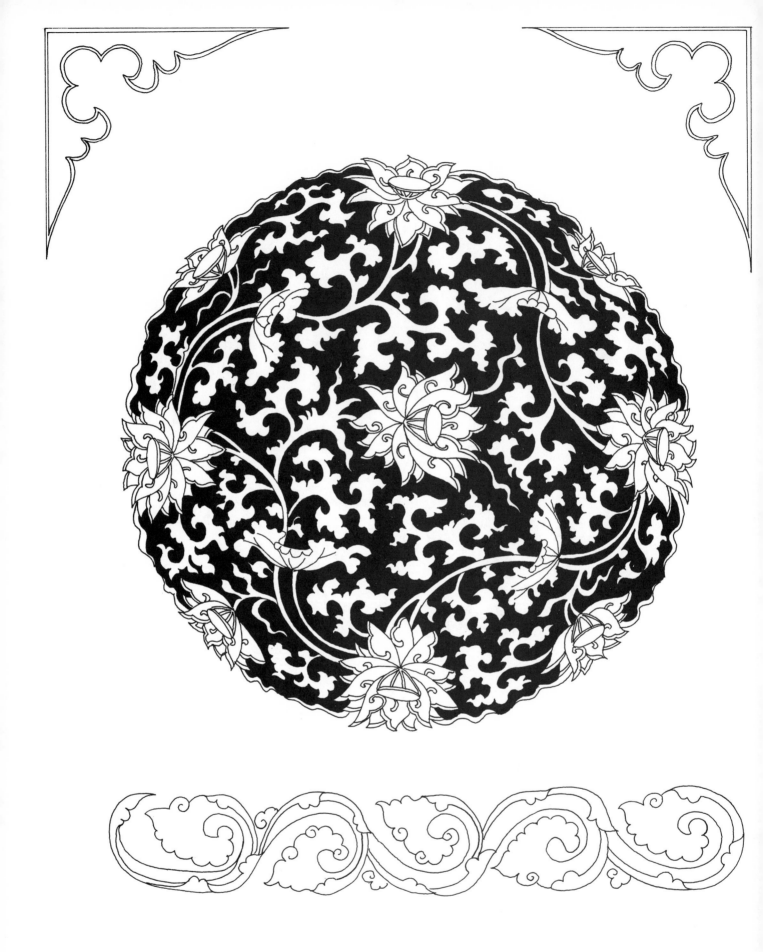

Dish, Kang xi period of the Qing dynasty. Top corner motifs from a Yuan dynasty porcelain.
BOTTOM: From a 19th-century (Qing dynasty) textile.